AMERICAN INDIANS

Stereotypes & Realities

Devon A. Mihesuah

CLARITY

In-house Editor: Diana G. Collier

Cataloguing in Publication Data:

Main entry under title:

Mihesuah, Devon A. (Devon Abbott), 1957-
 American Indians : stereotypes & realities

 Includes bibliographical references.
 ISBN 0-932863-22-1

1. Indians of North America - Popular opinions.
2. Stereotype (Psychology) - United States. 3. Public
opinion - United States. I. Title.

E77.M543 1996 973'.0497 C96-9200382

A co-publication of:

Clarity Press, Inc.
Ste. 469, 3277 Roswell Rd. N.E.
Atlanta, GA. 30305

and

Clarity International
Ste. 253, 919C Albert St.
Regina, SK. S4R 2P6
Canada

Table of Contents

ACKNOWLEDGEMENTS

I am sincerely grateful for the advice and suggestions from Curtis Hinsley, Professor of History at Northern Arizona University (N.A.U.), Flagstaff, Arizona; Shirley Powell, Professor of Anthropology and Archaeology Lab Director at N.A.U.; James Riding In, Assistant Professor of Justice Studies at Arizona State University in Tempe, Arizona; Donald Worcester, Professor Emeritus of History at Texas Christian University in Fort Worth, Texas; Dan Boone, photographer at the Bilby Research Center, N.A.U., and as always, my husband, Joshua.

LIST OF PHOTOS

To Joshua

INTRODUCTION

No other ethnic group in the United States has endured greater and more varied distortions of its cultural identity than American Indians. Distorted images of Indian culture are found in every possible medium — from scholarly publications and textbooks, movies, TV shows, literature, cartoons, commercials, comic books, and fanciful paintings, to the gamut of commercial logos, insignia and imagery that pervade tourist locales throughout the Southwest and elsewhere. Nor are the stereotypes consistent: they vary over time, and range from the extremely pejorative to the artificially idealistic, from historic depictions of Indians as uncivilized primal men and winsome women belonging to a savage culture, to present day Indians as mystical environmentalists, or uneducated, alcoholic bingo-players confined to reservations. It is little wonder, then, that we have misinformed teachers in our schools, who pass along their misconceptions to their students.

Not only Euro-Americans, but also Europeans, Africans, and Asians appear to have definite expectations of what Indians should look like. Indian men are to be tall and copper-colored, with braided hair, clothed in buckskin and moccasins, and adorned with headdresses, beadwork and/or turquoise. Women are expected to look like models for the "Leanin' Tree" greeting cards. These mental images are so pervasive that in the Southwest border town where I live, it is not uncommon for tourists to survey the downtown streets and ask where all the "real Indians" are, while short-haired Navajos dressed in jeans and cowboy boots stand right next to them.

Obviously, these images are not created from contact with real Indians. Most non-Indians still learn about Indians from movies. This influential medium often denigrates some Indians while elevating others to larger-than-life dimensions. Whether due to ignorance, lack of access to Indian advisers, or to the tendency to stereotype everything typical of American filmmakers whose primary interest is in making money, American films largely focus on those images that the public recognizes. Recent movies attempt to portray Indians more realistically than

the blatantly racist movies of the past decades such as *The Searchers* (1956), *The Unforgiven* (1960), and *White Comanche* (1968) but Hollywood still has a long way to go. In the movie *Dances With Wolves* (1990), for example, the Lakotas, a tribe popular among hobbyists and New Agers, are positively portrayed as people with human emotions, values, and spirituality, whereas Pawnees, whose culture is no less humane than that of the Lakotas, were insultingly characterized as barbaric. As so few movies portray Indians in their current circumstances, a movie so widely popular as this one tends to perpetuate the image of Indians as living in the world of the past, and however inadvertently, reinforces the belief that all Indians were just like the Lakotas of the northern plains. And of course, as is typical of earlier Hollywood productions concerning Indians, or indeed *any* non-European people, we still find that the lead female is Euro-American, and she falls in love with a Euro-American hero. Apparently the Euro-American public cannot watch a movie about Indians unless it is really about Euro-Americans. The hero and heroine ride off together at the end, leaving the Lakotas to their unpleasant fate. If the audience had been provided with a more fully historical rendering, including the fact that the Lakotas and other plains tribes were subdued and confined to reservations by the 1880s, it seems likely that the movie would not have been as successful.

Another controversial movie, *The Last of the Mohicans* (1992), not only focuses on the Euro-American stars (at the expense of the most interesting character, Magua), but gives the impression that the Mohicans (Mohegans) have disappeared. That is probably surprising news to the Mohegans, who still live in Connecticut. The Walk Disney production of *Pocahontas* (1995) epitomizes Hollywood's commercialized approach. The heroine absurdly sings with forest animals, is clothed provocatively (contrary to the modest dress typical of women of her tribe) and in true Disney fashion, is blessed with a Barbie doll figure. Disney has made an exorbitant amount of money from this happy image, yet that is all it is—an image. The movie ignores the reality that Pocahontas was only 12 at most when she met John Smith. She did not love him, she did not marry him, and she died at the age of 22 in England. Within twenty years after the period depicted in the movie, the Powhatan confederacy was practically

exterminated at the hands of colonists and disease. It will take years of cinema to mitigate the influence of the stereotypes that Hollywood has created for profit.

Many accurate books about Indians have been written, yet misinformation abounds and inundates our children at an early age. Racist television cartoons, which were drawn in the1940s and portrayed Indians as befeathered savages, are shown today as entertainment. As a result, children still play "cowboys and Indians." Were their games to reflect historical reality, they should be playing "United States army and Indians" since Indians and cowboys rarely fought each other. (Besides, the first cowboys were Mexican Indians.) Children pretending to be Indians grunt "ugh," which has grown into a nonsensical, verbal symbol of the quintessence of Indianness. Children tell each other not to be "Indian givers." This phrase implies that Indians took back what they gave. Many Indians suggest that this might more properly be changed to "U.S. government givers."

Textbooks have been and continue to be inadequate, even today, when one might have thought that certain historical realities had achieved common parlance. For example, students still learn in first grade that in 1492 Columbus "discovered" America, a land sparsely populated by heathens who had nothing to contribute to the world except corn, and that for 500 years after this encounter, all peoples of the Western Hemisphere have been content, despite the fact that this cultural encounter resulted in the most devastating holocaust the world has ever known. "Feel good" history appears to constitute the norm in our country's curriculum at all educational levels.

There are other ways teachers impart information about Indians to their pupils. Strongly influenced by the writings of prominent historians of yesteryear such as Frederick Jackson Turner, who saw Indians merely as obstacles to overcome in the spread of civilization and Christianity across the continent, they teach the "unrolling carpet theory," i.e. that it was inevitable that the tide of democracy, Christianity, and European superi- ority would unroll like a great carpet from east to west over a small, uncivilized population of inferior peoples. Professors who teach this version of history evaluate Indians by non-Indian standards. They still frequently refer to Indians as "savages," "heathens," and "red men," and never give the Indians' side of

the story. Many historians who study tribal histories and cultures never bother to consult with Indian informants in an attempt to formulate complete histories. Indeed, among scholars who write about Indians, the question of whether Indians can accurately recount their past is a major point of contention. Another approach followed by instructors who believe Indian culture to be unimportant is simply to ignore Indians. They teach their version of American history, sociology, art, law, literature, music, religion, political science, and education without referring to Indians at all.

There are, however, some teachers who, no less stereotypically, discuss Indians in a tone reserved for sinless martyrs. According to many Indian sympathizers, Indians were and are generous, nature-loving, noble savages, pure in heart and passive victims of the European onslaught, with no abilities to defend or think for themselves.

Thousands of Europeans belonging to over 100 "Indian enthusiast" groups are so captivated with the long-since-passed lifestyles of the Plains tribes that they gather together in camps to obsessively imitate the lifestyles of their idealized heroes. These European hobbyists or "Indianers" (Germans mainly) are disappointed to discover that Plains tribes do not live their lives as portrayed by the 19th century German pulp novelist, Karl May, as are German students who enroll in my classes in a steady stream. One summer I visited the Wupatki National Monument outside of Flagstaff and was amused to read the number of German names on the park's register that wrote in the space for comments, "Where are all the Indians?!" "I expected to see Indians." Wupatki has been deserted for almost 800 years.

Given this legacy of misinformation, it should not come as a surprise that our grade-school teachers cannot properly educate young people about the non-European segments of our society. Lacking a sound educational background in Indian history and culture, teachers often revert back to what they learned in elementary school. They have their students dress as Pilgrims and Indians for Thanksgiving, but fail to mention Indians again until they discuss the western pioneers who settled the country despite attacks from bloodthirsty savages. They also teach that Columbus was a hero without examining his treatment of the New World's indigenous peoples.

While some scholars contend that many of the more negative stereotypes have given way to more positive ones, it has been my experience that both positive and negative ideas are still held by men and women of all classes, races, and cultures. It appears that many non-Indians are still confused about Indians; they see them as simultaneously "noble" and "ignoble," just as the early European settlers did. Puritans in Massachusetts, for example, referred to Indians as the "Devil's disciples" to justify killing scores of Indians and taking their lands, yet many Puritans admired the tribes' cultures and preferred to live with Indians than within the oppressive Puritan society. Spanish conquistadors and colonists who lusted for the Indians' gold but wanted someone to mine it for them resolved both inconveniences that stood in their way by proclaiming Indians as subhuman and destined by God to be their slaves. At the same time, Spanish missionaries attempted to convert Indians to Christianity. Even humanitarians subscribed to the oxymoronic notion of the "Noble Savage," which asserted the intellectual ascendency of European civilization even as it appeared to invest Indians with a higher moral or spiritual stature.

Today, while university students understand and are saddened by the atrocities committed against Indians in our nation's past, they are still convinced that Indians enjoy benefits not available to others: they believe Indian students attend school *sans* tuition, regularly drink to excess, and receive free trucks from car dealerships. Many Americans believe Indians are lazy and on welfare, yet Euro-American collectors spend thousands of dollars to expand their collections of Indian art, rugs, and jewelry, clear evidences of Indians' artistry and industry.

Despite negative ideas about Indians, their images are used for profit. Indeed, the traditional dress, hairstyles, religious ceremonies, and fighting methods of tribes ignite the imagination, yet accurate details of tribes' cultural aspects become distorted in the hands of those attempting to imitate them for profit or amusement.

Non-Indian historians make lucrative careers out of writing about Indians, yet most are loath to actually talk to Indians about their versions of the past because many writers believe oral history is not an effective way to transmit knowledge. Euro-Americans and African-Americans who desire to be Indians

proclaim that they are "part Indian" without assuming any of the real social, economic, and political struggles that real Indians endure on a daily basis. Citizens of towns that derive considerable income from tourists attracted by their Indian population express their displeasure that Indians receive government funds while refusing to acknowledge the millions of dollars Indians spend in non-reservation grocery stores, shopping malls, restaurants, movies and car dealerships. New Agers obsessed with Indian religions rely on the ramblings of non-Indian, self-proclaimed "religious leaders" for advice while ignoring the complaints of real Indians that what they, the New Agers, are doing is intrusive and often sacrilegious.

Today in Santa Fe, one can attend a spa where an option is to exercise in an "aerobic kiva" or to perform pool aerobics to the sound of a "real chanting medicine man." Sweat lodge parties abound in the backyards of affluent denizens in this part of the state, and one of the activities in the men's movement is to chant and beat a drum. Many Americans want "something Indian" to display in their homes, while others hope to adopt Indian children. The Neiman Marcus Christmas catalog offers a "traditional Sioux teepee" for $2,200, while Spiegel's sells an "Indian and Daniel Boone Play Set." Indian art is popular, and is a lucrative business for many non-Indians (and a very few fortunate Indians). Americans often claim to have an Indian grandmother, and Indian scholars are continually asked to speak at library, church, and ladies' book club meetings about "anything to do with Indians." Since the late 1960s, hundreds of books of uneven quality have been published that focus on almost every aspect of Indian society. Indian Studies departments have been formed in many universities where the majority of enrollees are non-Indians. Sports teams fans of the Cleveland Indians and the Washington Redskins insult Indians with their drunkenness, dyed turkey feathers and sloppy face paint, screeching war hoops and spasmodic dance steps that belong to no tribe.

✳

I am a member of the Choctaw Nation of Oklahoma, born and raised in Texas and Oklahoma, and am employed as Associate Professor of American Indian History at Northern

Arizona University in Flagstaff. I do not claim expertise on Indian cultures and histories, but am sensitive to myths about Indians. I have found it easy to continually update my slide show on stereotypes of Indians; opportunities abound for photographs of mannequins dressed as Navajos in front of jewelry stores, fake tipis that advertise Indian novelties in roadside tourist shops, "Return of the Native" clothes that adorn models in fashion magazines, and tacky sports team mascots, to name a few.

As an educator and researcher, I favor an interdisciplinary approach to studying and teaching the truth about Indians—one that encompasses data from history (including oral histories), religion, anthropology, political science, statistics, economics, as well as including psychological and spiritual elements. Teaching also should encompass issues of race, class, and gender. But despite these good intentions, my attempts to dispel false images of Indians among students invariably meets with resistance. Each semester, a few students who do not want to hear about the atrocities committed against Indians in this country accuse me and other minority professors of being too "politically correct." Of course, these are the same pupils who become indignant when told that two of the four men on Mount Rushmore owned slaves, and that all four referred to non-Europeans as inferior to Europeans. I often wonder why these people cannot understand that if most classes don't mention Indians at all, a few courses focusing on Indians are vital in order to complete a full picture of United States history. This country's educational system needs to put more emphasis on under-represented ethnic groups, not less.

I began this book one evening after my husband and I discussed Indians with some tourists from England. My husband was wearing a tee shirt emblazoned with the Seal of the Comanche Nation, and one lady inquired where he obtained it. After replying that he bought it at the Comanche tribal complex in Lawton, Oklahoma, the woman was thoroughly bamboozled. If she could get a Navajo tee shirt here in Arizona, why could she not get a Comanche shirt at the same place? As do many non-Indians, she believed all Indians live on one big reservation together. I then decided to try to refute some of the most common myths about Indian peoples in book form that could be used by educators and by the public at large.

Indians are indeed multi-faceted peoples. Each tribe or nation has a complex past and present, and it is a mistake to generalize Indians, just as it is incorrect to generalize Europeans, Africans, Hispanics, or Asians. Because of the differences between tribes and diversity of the individual tribal members, discussing Indians is not easy. Indians as well as their cultures and traditions change over time, in response to the conditions around them. They are not static. New ideas meld with old ones. Indians are individuals and within each tribe are people who might be labeled traditional, progressive, mixed-blood, or fullblood. Members of the same tribe do not have the same adherence to traditional culture. Some Indians speak their tribal language and practice their religious ceremonies. Some know little about their culture because of disinterest or because they have not been raised in their tribal environment. In some cases, Indians are just like non-Indians in both appearance and in cultural adherence.

Terms also can be troublesome. The term "traditional," also. An Indian who still speaks his or her language and practices tribal religious ceremonies is often considered "traditional," but only traditional for this decade because chances are that he or she wears jeans, drives a car, and watches TV — very "untraditional" Indian things to do. Plains Indians who rode horses in the 1860s are considered traditional today, but were not the same as their traditional ancestors of the early 1500s who had never seen a horse.

There is debate over what to call the indigenous peoples of the United States ofAmerica. The terms "American Indians," "Native Americans," or "First Nations" are incorrect because these are European terms. It is preferable to refer to each tribe by its name, and certainly tribal members refer to themselves by their tribal names. For example, Navajos call themselves Dinee, the Chippewas — Anishinabeg, the Choctaws — Chatas, the Creeks — Muscogees, and so forth. However, as it's not feasible to list all 500 or so tribes every time I refer to the indigenous peoples of this country, American Indians will have to suffice as a way of referring to tribes or groups of Indian people.

This book is arranged by topic with a few suggested readings at the end of each section. There are hundreds of scholarly works that focus on particular tribes, individuals, time periods, and on every possible cultural aspect of Indian peoples, and more are

published every year; I have listed some of the most notable. One way to acquire lists of available books besides the local library is to write to university presses requesting their seasonal catalogs. Unfortunately, it is mostly non-Indian scholars, many of whom do not supplement their research by consulting with tribal people who know more about the topics than they do, who have written (and reviewed) most of these books. As a result, many works offer only the victors' side of the story, and are further cluttered with inaccuracies, embellishments, and racism—both subtle and blatant. Many of these books tell more about the persons writing them than they do about Indians. Unless readers are educated about the basic nuances of the tribe or topic of interest, they will not recognize misinformation when they encounter it.

This book is not intended to chronicle the history of any tribe or to analyze its culture, nor to detail intricacies of American Indian tribal politics, law, or economics. It is not intended to glorify Indians nor to criticize those people who believe the myths. Its purpose is to stimulate dialogue and to correct some of the most prevalent misconceptions about Indians. There are more, no doubt. But it is my hope that this book will spur teachers to fight for better textbooks—books that include a complete history of this country —and to push for multicultural curriculums. It is important for all of us to recognize and to combat stereotypes. All peoples deserve to have their histories and cultures properly placed in the scheme of things. Anything less does us all a disservice.

Recommended Readings:

Bataille, Gretchen, and Charles P. Silet. *The Pretend Indians: Images of Native Americans in the Movies.* (Ames, Iowa: Iowa State University Press, 1980).

Idem. Images of Indians on Film: An Annotated Bibliography (New York: Garland, 1987).

Berkhofer, Robert F. *The White Man's Indians.*(New York: Alfred A. Knopf, 1978).

Friar, Ralph and Natasha Friar. *The Only Good Indian . . . The Holly-wood Gospel.* (New York: Drama Book Specialists, 1972).

Green, Rayna. "The Tribe Called Wannabee: Playing Indian in America and Europe." *Folklore* 99 (1988): 30-55.

Hirschfelder, Arlene B. *American Indian Stereotypes in the World of Children: A Reader and Bibliography* (Metuchen, New Jersey: Scarecrow Press, 1982).

McNickle, D'Arcy. "American Indians Who Never Were." *The Indian Historian* 3 (1970): 4-7.

Slapin, Beverly and Doris Seale, comps. *Books Without Bias: Through Indian Eyes* 2nd ed. (Berkeley: Oyate Press, 1988).

Stedman, Raymond William. *Shadows of the Indians: Stereotypes in American Culture* (Norman: University of Oklahoma Press, 1982).

Taylor, Allan R. "The Literary Offenses of Ruth Beebe Hill"—a critique of *Hanta Yo: An American Saga* 4 (1980): 75-85.

"Writing About American Indians." *American Indian Quarterly* special issue, vol. 20#1 (1996). The *American Indian Quarterly* is a refereed interdisciplinary journal of the histories, anthropologies, literatures, and arts of Native North America. University of Nebraska Press, P.O. Box 880484, Lincoln, Nebraska, 68588-0484.

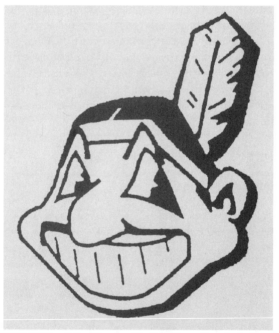

"Chief Wahoo," the Cleveland Indians' logo. Despite Indians' protests against using their images as sport mascots, dozens of teams continue to use unflattering, stereotypical symbols.

Indian dolls are for sale almost everywhere. Usually, they are incorrectly dressed and possess Caucasian features that are dyed brown *(Photo by Devon Mihesuah)*

STEREOTYPE
Indians are all alike

REALITY

In America alone, there are approximately 2.1 million Indians, belonging to 511 culturally distinct federally recognized tribes or an additional 200 or so unrecognized tribes. They live in a variety of environments, either on 286 U.S. reservations, or off reservation in rural areas or cities

Despite the cultural differences among tribes, many non-Indians believe that all Indians are alike. Lumping Indians together into one group presumed to have the same cultural and physiological characteristics is the same as assuming that all Europeans are alike, that they speak the same language, have the same heritage, and share the same values. Historic tribes differed substantially in regard to religious beliefs and practices, language, dress, hairstyles, physiology, political organization, social structures, gender roles, world view and living conditions in response to environment, which varied from forests, deserts, mountains, plains and coasts to subarctic and arctic areas. Even though today Indians live in the modern world (although some still live in what could be called a subsistence environment), Indians from one tribe are not the same as those from another, and often are indignant if mistaken by non-Indians as members of a tribe to which they don't belong. Because of the vast numbers of different cultures in existence, teaching an Indian history course—especially a survey—is quite difficult, insofar as each tribe has its own unique history and culture. Ideally, each tribe deserves its own course taught by one of its members.

At the time of European contact, almost 1,000 different tribes lived in North America (and many more in South America), speaking at least that many languages and countless dialects. Filmmakers and non-Indian artists, however, devote most of their attention to the Plains tribes that historically hunted bison and lived in tipis. But tribes in the west, New England, around the

Great Lakes, and the Arctic didn't live in tipis (or at least not in big, buffalo hide tipis). Most of them didn't wear their hair in braids, nor did they wear headdresses. Bison did at one time roam over most of this country, but over time their range was limited to the Plains and therefore not all tribes utilized them.

Scholars often categorized tribes by geographical regions (Great Plains, Southeast, Great Lakes, New England, Southwest, Great Basin, Southwest, Plateau, California) but that method of labeling can be misleading, for the tribes living within the same regions are not the same. Many tribes may have a few cultural traits in common, however. For example, Pueblo tribes may utilize pueblos, but each tribe is culturally distinct. Some tribes, such as the Navajos and Hopis, have their reservations literally next door to each other, but have completely different languages, physical appearances and traditional religions.

One of the most common symbols of "Indianness" is the tipi. Crows, Cheyennes, Pawnees, Poncas, Otos, Iowas, Kiowas, Comanches, Osages, and Sioux tribes, among others, lived on the Plains and many of them lived in tipis; the majority of North American Indians, however, never saw a tipi, much less lived in one. American Indians lived in a variety of structures, depending on their environment and available resources. The majority of Indians today live in "regular American houses".

The Pawnees, Arikaras, and Mandans lived in earth lodges, while the Wichitas inhabited grass houses. Southeastern tribes such as Choctaws, Cherokees, Lumbees, Muscogees (Creeks), Chickasaws, and Natchez lived in thatched-roof structures supported by wood poles, with walls made of wattle-and daub (a clay and grass mixture). Seminoles by the coast lived in chickees — also thatched roof and wall structures. After contact, wealthy members of some Southeast tribes, such as the Cherokees, built European-style houses and elaborate plantation homes. Tribes around the Great Lakes, such as the Menominees, Sauks, Foxes, Illinois, Miamis, Shawnees, Winnebagos, and tribes that made up the Huron, Abenaki, and Iroquois Confederations lived in longhouses, wigwams or earthhouses. Pueblos of the Southwest (Santa Ana, Hopi, San Felipe, Santo Domingo, Acoma, Laguna, Jemez, Taos, etc.) lived in pueblos, and some still do. These non-movable structures served as protection from other tribes, but their homes made them easy prey for Spaniards in

the late 1500s. Navajos, although they adopted many cultural traits from the Pueblos, lived (and some still live) in hogans of different variations, scattered over a vast region in modern New Mexico, Arizona and Utah. Apaches (Mescaleros, Mimbrenos, Jicarillas, Chiricuahuas, White Mountain, Coyoteros, etc.) were for the most part hunters and therefore lived in easy-to-build thatched huts, lean-tos, or wikiups. Other Southwestern tribes, such as Pimas and Tohono O'Odhams, lived in kis (structures made of mud and brush) in winter, and ramadas or brush arbors in summer. Many Pimas still live in houses that are built from boards, mud and brush pressed together called "sandwich houses." Utes, Paiutes, Shoshonis, Monos, Washos, and Hanjocks of the Great Basin were nomadic, and usually lived in wigwams. California tribes lived in a vast array of different homes made of pit, plank, earth, brush, or bark depending on the environment (coast, riverine, desert, forest, mountains). People of the plateau lived in pit houses, mat houses, and elongated tipis made of mat or cloth. Tribes along the northwest coast to Alaska primarily lived in plank houses made of split cedar and huge logs.

Tribes in Canada or the subarctic (Crees, Chippewas [Ojibways], Beavers, Slaves, and Kaskas, etc.) lived in areas of forest, treeless tundra, lakes, swamps, and rivers. They were nomadic, and lived in wigwams, domed houses — some semi-subterranean — in winter, and used snowshoes. Some in the southern regions lived in tipis covered by buffalo hides and those on the coast built elevated pole homes covered with walrus hide. Arctic tribes lived in a vast region of little vegetation and severe cold and are divided into six cultural provinces. Only those Indians in the east central areas of the arctic (non-Indians call them "Eskimos" but they prefer the name "Inuits") built shelters called iglus or igloos. These domed structures made of ice blocks served as temporary homes for hunters; they were not permanent dwellings. Most of the year they lived in earth covered, domed-roof homes of various shapes and sizes depending on wood availability.

Tribal economic pursuits varied from one region to the next. Not all Indians were hunters on horseback like most of the Great Plains tribes, and not all hunted only the bison. (Even Great Plains tribes did not acquire the horse until the mid-1600s or later.) Many tribes, like the Pueblos of the Southwest, were agriculturalists and others practiced a combination of hunting

and farming. For example, tribes in the lush, forested Southeastern United States supplemented their diets of deer, water fowl, fish and other small game by growing corn, squash and beans. While Great Lakes and New England tribes hunted bears, elk, moose, beavers and deer, they also fished, grew corn, pumpkins and tobacco, and conducted an extensive trade network among themselves. The Menominees of the shores of Lake Michigan gathered wild rice and made maple sugar to supplement their diets of fish and game.

Ten thousand years ago, during the Pleistocene Era, the Great Basin was filled with at least 68 lakes. Today, however, many of the lakes are gone and those left are filled with salt water. Tribes that lived in this harsh land hunted antelope, rabbits and almost anything else they could find, as did tribes living in the desert regions of California. In contrast, the tribes of the lush areas of California (literally hundreds of tribal groups) hunted, fished and collected acorns as a dietary staple, as did tribes of the plateau (Walla Wallas, Spokans, Yakimas and Nez Perce). In addition, the latter tribes depended upon the annual salmon runs for food. The dense populations along the northwest coast to Alaska fished along the shore, and hunted elk, seals and small whales. Inuits hunted sea and land mammals (not all lived by water) and utilized dogs to pull sleds.

Another common misconception about Indians is that they all carved totem poles and kachina dolls. The Coos, Alseas, and Chastacostas along the northwest coast used totem poles. However, tourist shops and museums that display these poles have given the impression that they are found throughout the country. These poles are not just for decoration. They serve as family crests, house the ashes of the dead, and are also used as "shame poles" to be erected in front of the homes of individuals who have done wrong. Not all tribes utilize Kachinas for spiritual purposes, either. To Hopis, Kachina dolls are the physical images of the spirit Kachinas that are the essence of all things in the material world. But Indians from other tribes and non-Indians commercialize the dolls, carving and selling them for profit. Hopis and serious collectors can tell who carved a particular kachina, but tourists who pay lots of money for an "authentic kachina doll" cannot recognize the difference between a doll made by a Hopi and one carved by a Navajo.

In addition to cultural variations, tribes dealt with non-Indians in different ways. After contact, many in the Southeast became active in the deer-hide trade while those in the Northeast and near the Canadian border exchanged fur pelts for European goods. Some formed uneasy alliances with either the British or French during the Colonial Wars (depending on which side promised to protect their lands and material goods). Many Indians intermarried with whites, producing populations of mixed-bloods that often adhered to the value system of their Euro-American fathers (Euro-American women rarely intermarried with Indian men during the Colonial Period). Some members of southeastern tribes became involved in the commercial production of cotton and purchased Africans who had been enslaved by the Euro-Americans to work their crops. But others who wanted nothing to do with Europeans fought to defend their lands against white intruders.

Today, individuals within tribes differ in many ways. There are mixed-bloods with light skin, hair and eyes contrasted with the often darker fullbloods. Progressives are often urbanized, educated Christians who know little or nothing about their tribal history or culture, while those known as traditionalists continue to practice their religious ceremonies, speak their native language, and have little to do with non-Indians and progressive members of their own tribe. Sometimes the mixed-bloods are traditional, while the fullbloods are progressive. Often mixed-blood Indians do not look phenotypically "Indian," and are therefore deemed non-Indian by non-Indians, who tend to consider only those individuals with long hair, beads, and a horse parked around the corner as Indians.

Ultimately, it is the tribes who determine their members.

Recommended Readings:

Baird, W. David. "Real Indians in Oklahoma?" *Chronicles of Oklahoma* 68 (Spring 1990): 4-23.

Berkhofer, Jr., Robert F. *The White Man's Indian: Images of the American Indian from Columbus to the Present* (New York: Random House, 1978).

Champagne, Duane. *Native America: Portrait of the Peoples* (Detroit: Visible Ink, 1994).

Cox, Bruce Alden. *Native Peoples: Native Lands: Canadian Indians, Inuits, and Metis* (Ottawa, Canada: Carlton University Press, 1988).

Debo, Angie. *A History of the Indians of the United States* (Norman: University of Oklahoma Press, 1970).

Gibson, Arrell. *The American Indian: Prehistory to the Present* (New York: D.C. Heath Co., 1980).

Helm, June. *Handbook of North American Indians – Subarctic* (Washington, D.C.: Smithsonian Institution, 1981).

Hodge, Frederick W. *Handbook of American Indians North of Mexico, American Ethnology Bulletin No. 30.* 2 vols. (New York: Rowman and Littlefield, 1971).

Kroeber, A.L. *Handbook of Indians of California* (Berkeley: California Book Co., 1953).

Nabakov, Peter, and Robert Eastman. *Native American Architecture* (New York: Oxford University Press, 1989).

Olson, James S., and Raymond Wilson. *Native Americans in the Twentieth Century* (Urbana: University of Illinois Press, 1986).

Parry, Ellwood. *The Image of the Indian and the Black Man in American Art, 1590-1900* (New York: George Braziler, 1974).

Prucha, Francis Paul. *A Bibliographic Guide to the History of Indian-White Relations in the U.S.* (Chicago: University of Chicago Press, 1977).

Idem. Indian-White Relations in the U.S.: A Bibliography of Works Published 1975-1980 (Lincoln: University of Nebraska Press, 1981).

Idem. The Indian in American History (New York: Holt, Rinehart and Winston, 1971)

Reader's Digest. *America's Fascinating Indian Heritage* (Pleasantville, New York: The Readers Digest Association, 1984)

Sturtevant, William, ed. *Handbook of North American Indians.* 20 vols. (Washington: Smithsonian Institution, 1978-)

Waldman, Carl. *Atlas of the North American Indian* (New York: Facts on File Publications, 1985).

Journals:

American Indian Quarterly, Department of Anthropology, University of Oklahoma, Norman, OK 73019.

American Indian Culture and Research Journal, American Indian Studies Center, 3220 Campbell Hall, University of California, Los Angeles, 405 Hilgard Avenue, Los Angeles, CA 90024-1548.

Ethnohistory, Duke University Press, 401 N. Buchanan Blvd., Box 6697 College Station, Durham, NC 27708.

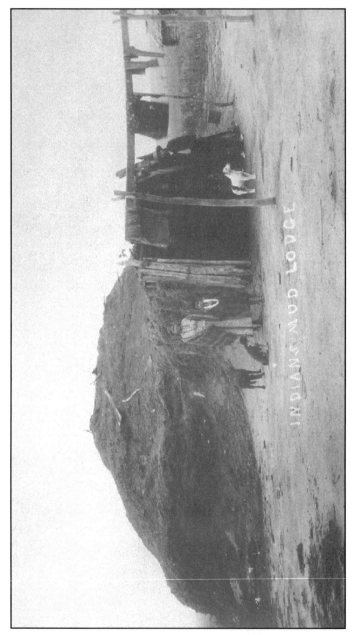

This Pawnee earth-covered lodge was a typical dwelling of seminomadic villagers who lived on the Plains (Courtesy of Oklahoma Historical Society)

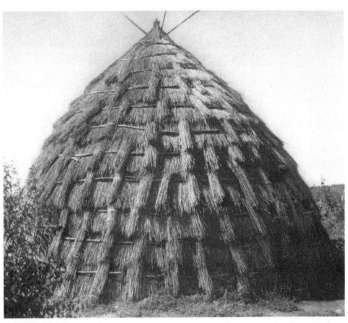

Grasshouses were used by tribes on the southern Plains. *(Courtesy Santa Barbara Museum of Natural History)*

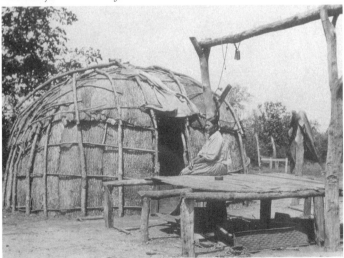

Potawatomi wigwams: Wigwams were utilized by tribes around the Great Lakes, the Northeast, and the Subarctic. They have round or oval bases with flexible poles forming the frame. This Potawatomi wigwam is covered with elm bark. *(Courtesy Denver Public Library).*

North American tribes at contact. Note that the majority of tribes were congregated around rivers and coastlines. (Courtesy of Bill Rieske, Hon. Doc., Historic Indian Publishers, Salt Lake City, Utah).

STEREOTYPE
Indians were conquered because they were inferior

REALITY
Indians were conquered because of their lack of immunity to European diseases

Many people believe that American Indian tribes were defeated by the Europeans because they were inferior to the invaders in every respect. While many Indians were destroyed by Europeans via warfare, and indeed some tribes were made extinct by others, the vast majority of Indians were conquered because they had no physical way to combat the myriad of diseases brought to them by Europeans, such as whooping cough, measles, mumps, smallpox, typhoid fever and influenza.

Prior to the invasion of America, there had been an interchange of diseases for thousands of years between Europeans, Africans and Asians—enough time for the systems of those populations to develop immunities and to survive diseases if they caught them, except for the young, old or very weak. American Indians, however, had been isolated from the Old World for tens of thousands of years. Thus, they had no immunity to the aforementioned diseases and died quickly after exposure to them. The first century after contact was the most disastrous; between 1520 and 1600, 31 major epidemics swept across the Atlantic Coast from South America to Canada. So devastating were these epidemics that the Indian population of North America fell from 7 million at contact to 3 million individuals within 100 years, while still greater losses in overall numbers occurred in the heavily populated regions of Mexico and South America, especially Peru. Europeans quickly learned of Indians' susceptibility to disease, and in 1763 British officers led by Lord Jeffrey Amherst (a college and numerous towns have been christened with his name) sent blankets infected with smallpox to Ottawas and other tribes in an attempt to quell Pontiac's uprising.

Indians who survived the biological invasion soon faced armed foes. Tribes with small populations and tribes with little weaponry were the first to be destroyed (although some tribal members survived and often intermarried into other tribes). The larger European forces, combined with horses (which the Indians had never seen), cannon, muskets and other arms, overpowered Indian warriors who were armed with tomahawks, spears, bows and arrows, or clubs. No amount of bravery on the part of the Indians could ultimately withstand a better-armed force, especially when they were outnumbered.

Even after tribes acquired the horse and European guns, they were still overcome by the sheer numbers of the European invaders, by their "divide and conquer" strategy, and by their treachery. For example, many tribes lost their lands when only a few members of a tribe were bribed, threatened, intoxicated, or gulled into signing a treaty with the Euro-Americans, who claimed that these two or three signatures (usually "Xs") validated the treaty. Often these signers did not understand the treaty terms. Nevertheless, the United States government held the entire tribe legally bound to honor the treaty, regardless of their protests.

Another example is that of the Plains tribes. Despite their fighting abilities and the northern tribes' defeat of George Armstrong Custer, Plains Indians were subdued in large part because their main source of food was systematically destroyed by hide hunting promoted by those who believed the death of the bison would mean death to the Indians. At the time of European contact, it has been estimated that there were 60 million bison. In 1880, that number had dwindled to 395,000, and in 1895 to less than 1,000.

Tribes also lost land through the unscrupulously administered General Allotment Act (also known as the Dawes Severalty Act) that was passed in 1887. Many congressmen and other Euro-Americans believed that one way to assimilate Indians (and indeed, to acquire fertile Indian lands) was to make them into Euro-American-style farmers by dividing the tribes' lands into small individual plots of approximately 160 acres for each head of family (with single women receiving less). All surplus lands (millions of acres) were to be auctioned off to Euro-Americans. Although these lands were said to be protected for Indians by

requiring the allotments to be held in trust for 25 years (meaning the Indians could not sell their lands during that time), they could lease their allotments. As a result, cattlemen allowed leased land to become over-grazed and timberland was clear-cut. In addition, many allotees could not speak English and had "guardians" appointed to make their decisions, many of whom coerced their charges to sign over their allotments to them in a will. Not surprisingly, many allotees died under mysterious circumstances. Subsequently, when other allotees died, their land was further subdivided between their heirs. Problems emerged by the 1920s, when heirship multiplied and many allotments were divided by hundreds of people. Unquestionably, the Dawes Act was a disaster for Indians: of 138 million acres left to Indians in 1887, 90 million of those acres were lost through the allotment process.

It must not be misconstrued that American Indians were helpless victims of the European expansion. Many groups offered staunch resistance and proved difficult to defeat. The Seminoles of Florida, for example, resisted removal to Indian Territory. Led by Osceola, rebels moved into the swamps and, joined by Africans fleeing Euro-American enslavement, were able to fight and elude U.S. troops in the Everglades from 1835 to 1837, when they finally surrendered due to lack of food and ammunition. They signed a peace treaty with the U.S. in 1956.

The Apaches offer another example of strong resistance to federal policy. From 1861 to 1886, 24 or so Chiricahua Apaches led by a Bedonkohe Apache named Goyanthlay (otherwise known as Geronimo) eluded 5,000 U.S. troops, 500 Indian scouts, and 1,000 militia after leaving their reservation at San Carlos on the Gila River in Arizona. They eventually surrendered in 1886 because General Nelson A. Miles had imprisoned their families. These Apaches, including, ironically, many of the scouts who had helped U.S. troops locate Geronimo, were exiled to Florida.

In order to force unwilling Navajos to surrender their lands to Euro-American settlement in 1863-64, General James Carleton (who referred to Navajos as no better "than the wolves that run through their mountains") ordered his troops to cut down the tribes' corn fields and peach orchards, and to slaughter or capture their animals. Led by Manuelito and Barboncito, the Navajos

fought until they were on the verge of starvation. In March of 1864, about 8,000 Navajos were then forced to march the "Long Walk" from their stronghold at Canyon de Chelley to the infamous Bosque Redondo prison camp near the Pecos River in New Mexico.

Other examples abound of tribes who resisted Euro-American encroachment onto their lands and into their cultures. Prominent encounters include the War for the Bozeman Trail (Arapahos, Cheyennes and Sioux) in 1866-68; the Snake War (Northern Paiute bands) from 1866 to 1868; Hancock's Campaign (Cheyennes and Arapahos) in 1867; Southern Plains War (Arapahos, Cheyennes, Comanches, Kiowas and Sioux) from 1868 to 1869; the Modoc War in 1872 and 1873; the Red River War (Cheyennes, Comanches and Kiowas) in 1874 and 1875; the Sioux War (Arapahos, Cheyennes and Sioux) from 1876 to 1877; the Flight of the Nez Perces in 1877; the Bannock War (Bannocks, Cayuses and Northern Paiutes) and the Northern Cheyenne's flight to Wyoming and Montana in 1878; the Ute War in 1879; and various Apache Wars throughout the 1870s and 1880s.

As early as the mid-nineteenth century, some tribes had members who became lawyers, businessmen, politicians and teachers, who attempted to fight their enemies in court, in industry, in government and in the classroom. More recently, Indians have founded numerous organizations in order to perserve their cultures and rights, such as the Native American Rights Fund, National Congress of American Indians, the American Indian Movement, Alaska Federation of Natives, the International Indian Treaty Council, Council of Energy Resource Tribes, American Indians Against Desecration, Women of All Red Nations, in addition to other political, educational, and legal organizations.

Recommended Readings:

Debo, Angie. *And Still the Waters Run: The Betrayal of the Five Civilized Tribes* (Norman: University of Oklahoma Press 1989).

Fritz, Henry. *The Move for Indian Assimilation* (Philadelphia: University of Pennsylvania Press, 1963).

Jackson, Helen Hunt. *A Century of Dishonor: The Early Crusade for Indian Reform* (New York: Harper and Row, 1965).

Limerick, Patricia Nelson. *The Legacy of Conquest: The Unbroken Past of the American West* (New York:W.W. Norton and Co., 1987).

Thompson, Gerald. *The Army and the Navajo* (Tucson: University of Arizona Press, 1976).

Thornton, Russell. *American Indian Holocaust and Survival: A Population History Since 1492* (Norman: University of Oklahoma Press, 1987).

Worcester, Donald. *The Apaches: Eagles of the Southwest* (Norman: University of Oklahoma Press, 1979; paperback edition, 1992).

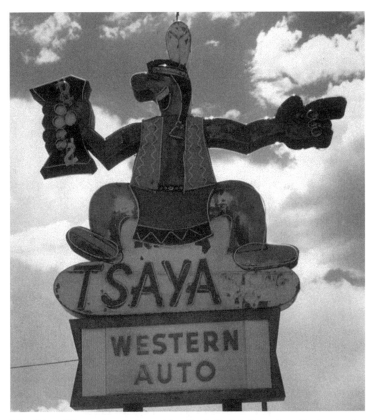

The "Tsaya" logo of an Indian with a fist full of dollars gives the impression that Indians are greedy. This advertisement is displayed in the Southwest, but the character's clothing and hair is Plains-style. *(Photo by Devon Mihesuah)*

STEREOTYPE
If Indians had united, they could have prevented
the European invasion

REALITY
**Tribes were too different culturally and lived too far
apart to fight together as a cohesive unit**

This hypothetical question continues to arise year after year in my Indian history survey classes. Certainly, if all the millions of Indians of the Western Hemisphere had formed a huge military unit on the isle of San Salvador in 1492, they would not only have made a spectacular sight (if all of them could have fit on the small island, that is), they would have deterred Columbus and Company from coming ashore. But there are many obvious problems with this scenario.

Because of the religious, political, economic, linguistic, and social differences between tribes, it is doubtful that they could have tolerated one another for any length of time. Who would be the leader? How would they understand each other if they spoke different languages? Could the area support so many people for even a short time? How could the tribes have anticipated Columbus' intentions? How would messages be transmitted thousands of miles? How could they navigate the waters? Considering the devastation caused by European diseases, chances are the entire Indian population of the Americas might have been destroyed in one fell swoop without much warfare. In addition, as time passed, more Europeans would arrive along the coasts; it would have been impossible for tribes to unite and reassemble every time another ship came into sight.

There have been relatively few times in American history when tribes banded together in large numbers for any lengthy period. In 1521, Hernando Cortez and his conquistadores overcame the Aztec empire with help from European diseases, as well as from enemy tribes. Almost 60 Pueblo tribes in the

Southwest united in 1680 in an attempt to rid themselves of Spanish missionaries and colonists. That revolution succeeded for at least ten years. The Iroquois Confederation, consisting of Senecas, Mohawks, Oneidas, Onondagas, Cayugas, Tuscaroras and numerous smaller tribes, dominated the eastern Great Lakes area from the late sixteenth century until the end of the American Revolution and served as a balance of power during the French and Indian Wars (1689-1783). That confederacy disbanded after the American colonists prevailed. The Huron Confederacy, centered around the Georgian Bay region of Lake Huron, was composed of a least four tribes and 25,000 people in 1600. The Creek Confederacy in the Southeast consisted of numerous small tribes and almost 20,000 individuals by 1500. The Powhattan Confederacy of the tidewater region of Virginia, consisting of 32 tribes and at least 200 villages, was capable of destroying the Jamestown colony in 1607 but did not. In 1791, 2,000 Chippewas, Delawares, Miamis, Ottawas, Shawnees and Wyandots killed 600 of Arthur St. Clair's troops in western Ohio; this is known today as "Saint Clair's Defeat," the worst defeat of United States troops at the hands of Indians. During the War of 1812, the Shawnee leader Tecumseh managed to unite a good number of eastern tribes against the advancing tide of Euro-Americans for a short time. Teton Sioux, Santee Sioux, Northern Cheyennes and Northern Arapahos united against the breaking of their 1868 Treaty of Fort Laramie, but their defeat of Custer was the Indians' last hurrah, because soon afterward the bison were almost gone, and the Indians were divided and forced onto reservations.

Today, in an effort to find ways to help all Indian peoples, representatives of various tribes do serve together on committees, in organizations, at American Indian centers, and on protest marches, but these individuals retain their separate tribal identity. There are many intertribal agreements wherein tribes cooperate on economic or social service enterprises. Some of the largest national organizations comprised of Indians of different tribes include the National Congress of American Indians, the Native American Rights Fund, the American Indian Movement, and the National Indian Youth Council. No one person speaks for all tribes, and often, no one individual speaks for all members of one tribe.

Recommended Readings:

Aquila, Richard. *Iroquois Restoration: Iroquois Diplomacy on the Colonial Frontier, 1701-1754* (Detroit: Wayne State University Press, 1983).

Corkran, David. *The Creek Frontier: 1540-1783* (Norman: University of Oklahoma Press, 1967).

Graymont, Barbara. *The Iroquois in the American Revolution* (Syracuse: Syracuse University Press, 1972).

Hunt, George T. *The Wars of the Iroquois* (Madison: University of Wisconsin Press, 1967).

Jacobs, Wilbur. *Wilderness Politics and Indians' Gifts: The Northern Colonial Frontier, 1748-1763* (Lincoln: University of Nebraska Press, 1950).

Jones, Okah. *Pueblo Warriors and the Spanish Conquest* (Norman: University of Oklahoma Press, 1966).

Leach, Douglas. *Flintlock and Tomahawk: New England in King Phillip's War* (New York: Norton and Co., 1958).

Morgan, Lewis. *The League of the HO-DO-NO-SAN-NEE or Iroquois* (New York: Burt Franklin, 1968).

Trigger, Bruce. *The Huron Farmers of the North.* (New York: Holt, Rinehart and Winston, 1969).

STEREOTYPE
Indians had no civilization until Europeans brought it to them

REALITY
Indians were civilized. Their cultures were different from those of Europeans

Tribes have had their own cultures and civilizations at least as long as non-Indians have had theirs. Some of my Navajo students have complained to me about a professor who told them they had no real culture until the Europeans brought it to them. This is not too surprising, for since the encounter, both Europeans and Indians have judged each others' cultures to be inferior to their own. Even before contact, many tribes viewed (and still do view) other tribes' cultures as inferior to theirs, and the same can be said about the various European cultures. The belief that one's race and culture is superior to all others is called "ethnocentrism." Euro-American ethnocentrism played a large role in the widespread destruction of Indians and their cultures, and continues to afflict them to this day.

"Civilization" is a problematic term, insofar as Europeans have largely regarded civilization as an advanced stage in social development distinguished by thought systems and other features unique to modern European societies. This in turn influenced and continues to influence a negative evaluation of other societies as "uncivilized," "primitive," or (more lately) "underdeveloped" due to the absence of certain modern European features. However, even if one accepts the popular Webster definition of civilization as: "a relatively high level of cultural and technological development; the stage of cultural development at which writing and the keeping of records is attained;" or "refinement of thought, manners, or taste;" or " a situation of urban comfort" — it is evident that most tribes had civilizations that fit this definition. The Aztecs of Mexico, for example, built spectacular pyramid-shaped temples, canals, bridges, ball courts and intricate urban designs. Individual homes

made of sun-dried bricks featured courtyards and gardens, while the emperor Montezuma lived in a monumental palace with fountains, gardens, an aviary, and private zoo. Most Aztecs bathed at least once a day—considerably more often than Europeans did at that time—and wore elaborate hairstyles, clothes and jewelry of copper, silver and gold. The Mayas, who preceeded the Aztecs, constructed fabulous pyramids and developed calendrical and mathematical systems.

Tribes across the country were successful farmers, developed extensive trade networks with each other, and were devoutly religous. The ancient Hohokam culture of southern Arizona built extensive irrigation canals landmarked today by Phoenix's modern metropolitan canal system. The Iroquois Confederacy maintained a strong political system which united separate Indian nations and profoundly influenced America's Founding Fathers. Two tribes, the Maya and the Cherokee, developed their own written languages. All tribes have a strong oral tradition, but this is discounted as a primitive method of transmitting history and culture.

Most tribes were egalitarian societies. Men and women had different social and labor roles (women worked the fields and bore children, while men hunted and participated in warfare), but the jobs were considered as equal in importance. Unlike the stratified societies in Europe, among tribes, each sex had its own decision-making powers. Despite the level of advancement and "comfort" reached by many tribes, along with their "refinement of thought, manners, and taste," Europeans still perceived the Indians as "uncivilized" — a term that alludes to "savage," "wild," "heathenistic," and worse. Thinking that Indians were savages helped some Europeans rationalize tribes' destruction and the expropriation of their lands.

Another European belief was that Indians were uncivilized because they were "doing nothing" with their lands. Philosopher John Locke, in his second of *Two Treatises of Government*, wrote that land should be put to profitable use. Alexis de Tocqueville wrote in *Democracy in America*, that the tribes of North America "had no thought of profiting by the natural riches of the soil; that vast country was still, properly speaking, an empty continent, a desert land awaiting its inhabitants." On the contrary, this vast "still" country was indeed active, and was

populated by millions of people with unique and important cultures and civilizations.

Roy Harvey Pearce, in his book *Savagism and Civilization,* writes that upon encountering Indians, Europeans immediately felt superior to them in every respect. Strongly influenced by their Rennaisance, which stressed bringing order out of chaos, most Europeans believed that Indians were either 1) at a lower rung of civilization's ladder from Europeans and would eventually work their way up or 2) had previously been civilized but had somehow degenerated. Europeans were confused as to where Indians fit into the scheme of humankind. Some Europeans believed that they could help Indians to progress toward true (ie. European) civilization, and could assist them in assimilating into Euro-American society by simply teaching them to become Christians and farmers. Ironically, a good portion already were farmers but Europeans tended to overlook this fact. Others believed that Indians could not be assimilated, and would eventually die out in the face of white advancement. Still others thought that Indians should be removed from Euro-American society onto reservations where they could survive without hindering white progress.

In the early-to-mid 1800s, many ethnologists, such as Samuel G. Morton (and lay-people such as President Thomas Jefferson), believed that the so-called Caucasian race was superior to all other races and embarked on a crusade to prove it by conducting "Indian Crania Study." This required a supply of Indian craniums, so after the U.S. Army completed its routing of tribes (such as the Massacre at Sand Creek in 1864, where hundreds of Cheyennes were brutally dispatched by troops led by a Methodist minister, Colonel John Chivington), Indians were decapitated and their heads sent to the Smithsonian Institution. These standard-bearers of civilization sought the data they wanted by such bizarre (and flawed) methods as measuring the amount of sand or mustard seed that would fill a cranium. More sand or seed meant a larger cranium and a higher intelligence, and many so-called "scientists" thereby concluded that Indians, African-Americans and other non-Europeans were inferior species. They also espoused the theory of "polygenesis,' that each race descended from its own Adam and Eve.

Upon contact with Indians, Euro-Americans developed a variety of self-serving opinions about the levels of savagery in which Indians were immersed. Most Euro-Americans either wanted Indian lands or desired to capture Indian souls for their particular religion, and were willing to remove or eradicate anyone in their way. Like other British colonists who wanted land, Puritans viewed Indians as Satan's disciples since they were not Christians, lived in the "wild," and danced. To Puritans, Indians appeared as obstacles to the spread of the version of Christian civilization ordained by their God for the new world, and they were therefore able to believe it was God's will that Indians be destroyed. One 17th century English philosopher, Thomas Hobbes, believed Indians to be "brute savages," yet another philosopher, John Locke, at least thought they were intelligent savages.

The French believed in the myth of the "beast men" and of Indians as *bon sauvage* (Noble Savage). French trappers were somewhat more tolerant of Indian cultures and many married Indian women and adopted Indian customs and lifestyles. Still, the French were happy to use tribes to obtain animal pelts and to turn tribes against each other to gain allies during the Imperial Wars of the late 17th and most of the 18th centuries.

When Hernando Cortez and his company of conquistadores encountered the million or so Aztecs of Tenochtitlan (today known as Mexico City) and surrounding areas in 1519, they were dazzled by their beautiful and sophisticated city, and their culture. Granted, the Aztecs did perform human sacrifices, which shocked the Spaniards (and most of us who have read about this aspect of their culture), but the Spanish did not understand the web of socio-political needs and religious meanings that had led the Aztecs to accept sacrifice as a necessary part of their religion and culture. In turn, Aztecs did not understand the Spaniards' insatiable greed for gold, their penchant for torturing Aztecs to get information about where it was hidden, and their willingness to slaughter large numbers in order to carry off the ornate metal. Further south, the Portuguese in Brazil forced Indians to work in gold mines, and would lop off a foot or other extremity as a punishment or to keep workers from running away.

The Spanish debated among themselves on the "humanity" of American Indians. In 1550, at Valladoliad, Spanish scholar Juan Gines de Sepulveda and Spanish priest Bartolome de Las Casas argued for over a month over whether Indians were supposed to be slaves of the Europeans, or if they really were men, not monkeys, and capable of rational thought. Las Cases' sympathetic view of Indians did not find much support, for in the subsequent decades, popular Spanish opinion was that Indians were no more advanced than animals.

Euro-Americans had a curious way of demonstrating the superiority of their civilization. The Dutch traders and colonists, and their outspoken anti-Indian leaders provoked the incredibly gory Pavonia Massacre (also known as "The Slaughter of the Innocents") in 1643, and manipulated the powerful Iroquois Confederacy to acquire furs at the expense of smaller tribes. The violent and abusive Russians sailors and trappers who hunted along the eastern coast of Siberia from 1700 to 1867 also wanted furs, and proceeded to murder, rape and torture thousands of Aleuts in order to get them. The Aleut population plummeted so dramatically at the hands of these invaders that the Russian court finally interceded and ordered a halt to the abuses. However superior their weaponry may have been, the fur-hungry Russians demonstrated their lack of knowledge of ecology by decimating the animal population and ecosystem of the area.

Since colonial times, missionaries from European countries attempted to "civilize" Indians by converting them to Christianity. Throughout the nineteenth century, missionaries established schools on Indian lands and made numerous converts. In the 1870s, the government began a campaign to assimilate the Indians. Boarding schools were established with the intention of taking young Indians from their homes and placing them in schools hundreds of miles away. One example was Carlisle Industrial Indian School in Pennsylvania. Established by Army Captain Richard H. Pratt, Carlisle was to serve as an example of how military discipline, harsh punishment, and rigorous studies could "kill the Indian and save the man." By the end of the 1800s, there were at least 20,000 Indians enrolled in 148 boarding schools.

Indians who were forced to attend these schools suffered major hardships and handicaps: the inability to communicate

41

with teachers, a lack of parental involvement and support, the loss of contact with their culture, and poor diets. Students were not allowed to speak their tribal languages, wear their hair long, or practice their religions. Transgressors were whipped and slapped. Many students ran away while others committed suicide. Some completed the educational programs, but ironically were still not accepted as equals in Euro-American society because they were Indians. Still others returned to their homes as educated Indians, no longer adherent to their traditional culture, nor were many tribal members willing to accept their new world view.

It is true that tribes' cultures were dramatically changed after contact with Europeans, but these changes were not always positive ones. The first change included a sensational population decline after the introduction of European diseases which drastically altered the tribes' structures. Europeans quickly dispossessed Indians of their lands, causing further confusion and instability.

Tribes also became dependent upon European material goods such as metal utensils, knives, needle and thread, guns and ammunition. In order to acquire these items, Indians began fighting amongst themselves in competition for trade with Europeans. In some areas, tribes almost hunted some fur bearing animals into extinction. Indians consumed alcohol in unprecedented quantities, further weakening tribes' mental and physical health.

Missionaries and non-clerical diplomats, in attempts to woo Indians to their way of thinking, caused rifts between progressive and traditional tribal members. The adoption of European cultural mores, especially religion, created a new form of prejudice between tribal members: "culturalism" — the idea that the cultural adherances of some are superior to those of others. Indians who converted to Christianity became known as the "saved" Indians, and those who continued traditional practices as the "heathens." Many saved Indians became imbued with a strong sense of misson to save their "backward" tribesmen — something traditional Indians did not desire.

Social positions within the tribes changed because of European influences. The egalitarian tribal societies slowly shifted to stratified ones. With the adoption of European customs

came an unequal access to tribal resources, power, and prestige. Some tribal members were forced to defer politically, socially, and economically to other members. Men gained positions of power in all spheres of tribal life, relegating women to sub-serviant positions.

If the European influence was negative, why did Indians adopt their maners and customs? To be sure, many had no desire to become like Europeans, but those who did often believed they had no other choice. Many Indians thought that by becoming as much like Europeans as possible, they could compete with the invaders on their own terms. Others may have believed that the Europeans were more powerful than the Indian tribes and that assimilation offered their best chance at survival. Still others, because they were of mixed-heritage and appeared Caucasian, knew they could fit into Euro-American society and took advantage of their physiological appearance. Whatever their reasons, it is open to speculation as to how tribes' cultures might have evolved without European influence.

Regardless of what Europeans thought of them, North and South American tribes had their own sophisticated systems of government, community organizations, economy, means of communication, gender roles, arts, and elaborate clothing and hairstyles. Indians were and are extremely religious; ceremonies and rituals were and are a part of their daily life. They laugh, cry, share, dream, interact, worry, love and plan like other humans. The key word regarding the myth of Indians not being "civilized" is *different*. Indians' cultures and civilizations were *different* from European cultures and civilizations, not inferior.

Recommended Readings:

Axtell, James. *Beyond 1492: Encounters in North America* (New York: Oxford University Press, 1992).

Berkhofer, Robert F. *Salvation and the Savage: An Analysis of Protestant Missions and American Indian Response, 1787-1862* (Lexington: University of Kentucky Press, 1965).

Idem. The White Man's Indian: Images of the American Indian From Columbus to the Present (New York: Vintage Books, 1978).

Bieder, Robert E. *Science Encounters the Indian, 1820-1880* (Norman: University of Oklahoma Press, 1986).

Coleman, Michael C. *American Indian Children at School: 1850-1930* (Jackson: University of Mississippi Press, 1993).

Cronon, William. *Changes in the Land: Indians, Colonists, and the Ecology of New England* (New York: Hill and Wang, 1983).

Deloria, Vine. *God is Red* (New York: Dell Publishing Co., 1983).

Dickason, Olive Patricia. *The Myth of the Savage and the Beginning of French Colonization in the Americas* (Edmonton: University of Alberta Press, 1984).

Gibson, Charles, ed. *The Black Legend: Anti-Spanish Attitudes in the Old World and the New* (New York, 1971).

Jacobs, Wilbur R. *Dispossessing the American Indian: Indians and Whites on the Colonial Frontier* (New York: Charles Scribner's Sons, 1972).

Jennings, Francis. *The Invasion of America: Indians, Colonialism, and the Cant of Conquest* (Chapel Hill: Univ. of North Carolina Press, 1975).

Leon-Portilla, Miguel, ed. *The Broken Spears: The Aztec Account of the Conquest of Mexico* (Boston: Beacon Press, 1962).

Marcshall, Peter C. *Deadly Medicine: Indians and Alcohol in Early America* (Ithaca: Cornell University Press, 1996)

Pearce, Roy Harvey. *Savagism and Civilization: A Study of the Indian and the American Mind* (Baltimore: John Hopkins Press, 1953).

Idem. The Savages of America, A Study of the Indian and the Idea of Civilization (Baltimore: John Hopkins Press, 1965).

Peckham, Howard, and Charles Gibson. *Attitudes of Colonial Powers Toward the American Indian* (Salt Lake City, Utah, 1969).

Peterson, Frederick A. *Ancient Mexico: An Introduction to the Pre-Hispanic Cultures* (New York: G.P. Putnam's Sons, 1959).

Pratt, Richard Henry. *Battlefield and Classroom: Four Decades With the American Indian, 1867-1904*, ed. (Lincoln: University of Nebraska Press, 1987).

Prucha, Francis Paul. *American Indian Policy in Crisis: Christian Reformers and the Indian, 1865-1900* (Norman: University of Oklahoma Press, 1976).

Rawls, James J. *Indians of California: The Changing Image* (Norman: University of Oklahoma Press, 1984).

Salisbury, Neal. *Manitou and Providence: Indians, Europeans, and the Making of New England, 1500-1643* (New York: Oxford University Press, 1982).

Sheehan, Bernard. *Savagism and Civility: Indians and Englishmen in Colonial Virginia* (Cambridge: Cambridge University Press, 1980).

Szasz, Margaret. *Indian education in the American Colonies, 1607-1783* (Albuquerque: University of New Mexico Press, 1988).

Takaki, Ronald. *A Different Mirror: A History of Multicultural America.* (Boston: Little, Brown And Co., 1993).

Tocqueville, Alexis de, Philip Bradley, ed. *Democracy in America* (New York: Vintage Books, 1945).

Stannard, David E. *American Holocaust: The Conquest of the New World* (New York: Oxford University Press, 1992).

Utley, Robert M. *The Last Days of the Sioux Nation* (New Haven: Yale University Press, 1963).

Vaillant, George C. *Aztecs of Mexico: Origins, Rise, and Fall of the Aztec Nation* (Garden City, NY: Doubleday, 1941).

Vaughan, Alden T. *New England Frontier: Puritans and Indians, 1620-1675* (Boston: Little, Brown & Co., 1965).

Williams, Robert A. *The American Indian in Western Legal Thought: The Discourses of Conquest* (New York: Oxford University Press, 1990).

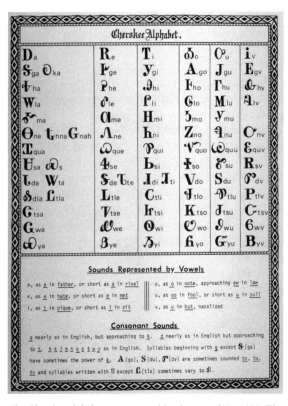

The Cherokee alphabet was created by Sequoyah in 1822. The syllabary consists of 86 symbols, each representing a Cherokee syllable. The Cherokee tribe was the only tribe to have its own alphabet.

STEREOTYPE
Indians arrived in this hemisphere via the Siberian land bridge

REALITY
Indians believe that they were created in this hemisphere

According to archaeologists, during the Pleistocene Era much of the oceans froze into glaciers, lowering the sea level almost 300 feet, forming a land bridge between Siberia and Alaska. They postulate that during this time, groups of people followed animal herds over the bridge, across northern Alaska, and down the east slope of the continental divide through the American Southwest, a passage relatively free of ice. This land bridge disappeared around 10,000 B.C. when the glaciers melted, the oceans rose, and the continents were separated. The various peoples then spread throughout the Western Hemisphere, and some were at the southern tip of South America by at least 12,000 B.C.. These nomads were the ancestors of the American Indians.

Anthropologists did not always believe this. During the two decades prior to the Civil War, aforementioned ethnologists such as Samuel G. Morton and Josiah C. Nott espoused the theory of "polygenesis" — that each race descended from its own Adam and Eve, and that all races were inferior in every respect to what was termed the Caucasian race. Those who believed this theory also thought Indians were created in this hemisphere. On the other hand, the supporters of "monogenesis" — the theory that we all descend from common ancestors — believed that Indians had to have migrated from the Old World because, in their estimation, Indians could not have created their own civilizations without Old World influence.

Regardless of archaeology's arguments, many Indians refute the migration theory. Each tribe has its own creation story and most are complicated. Some tribes believe that they emerged from this continent from sacred, underground sites. One theme that runs through some tribes' creation story is that the world

was first covered with water, then living beings — animals mostly — brought mud from the bottom to form the earth before humans emerged from the underground. These places of emergence are revered as sacred sites. Others believe they were created by the union of divine figures or emerged from the sky. Some believe that they were created by the stars and placed in the Western Hemisphere. In other words, tribes universally recognize the Western Hemisphere as their motherland.

Obviously, these beliefs were and are not in accordance with Christian traditions. While it is only in relatively recent history that Christian creationism has come into question, the Indian versions of creation have always been dismissed. Indians' dissimilar versions as to how they came to be in the Americas have led to serious points of contention between Indians and anthropologists. Among them is the readiness of many archaeologists to argue that insofar as the Siberian land bridge theory proves we all have the same common ancestors and are all related, Euro-American researchers have the right to exhume, study, and hold Indian remains and sacred burial objects in perpetuity in the name of science. A further implication of what might seem an apolitical archaeological theory is that inasmuch as Indians too are immigrants to the western hemisphere, albeit arriving earlier than the rest, their aboriginal claim on lands widely alleged by earlier Europeans to be vacant is diminished.

Recommended Readings:

Erdoes, Richard, and Alfonso Ortiz, eds. *American Indian Myths and Legends* (New York: Pantheon Books, 1984).

Fladmark, K. "Routes: Alternative Migration Corridors for Early Man in North America." *American Antiquity* 44 (1979): 55-69.

Greenberg, J.H., et al. "The Settlement of the Americas: A Comparison of the Linguistic, Dental, and Genetic Evidence" *Current Anthropology* 27 (1986): 477-497.

Meltzer, David J. "Why Don't We Know When the First People Came to North America?" *American Antiquity* 54 (1989): 471-490.

Mihesuah, Devon. "Despoiling and Desecration of American Indian Property and Possessions," *National Forum* (Spring 1991): 15-18.

STEREOTYPE
Indians were warlike and treacherous

REALITY
**Indians fought to defend their lands,
sovereignty and way of life from invaders**

The belief that it is in Indians' nature to fight is one of the most pervasive images of this country's native peoples. While the history of Indian-Euro-American relations is filled with instances of European massacres of Indians, in movies and on television, it is always the Indians who are portrayed as bloodthirsty villains. Endlessly we see them circling the wagon trains, waiting to massacre innocent pioneers without the slightest provocation. What can we conclude but that such seemingly irrational barbarism reflects a warlike nature? The "tomahawk chop," the motion made by fans of the Atlanta Braves, symbolizes the killer instinct stereotype. Loud, roughhousing children are told not to act like "wild Indians," while fathers and sons like to "Indian wrestle."

Wars have been common to all social groups, but to some more than others. Europeans had a long history of wars on their own territories before they laid claim to the western hemisphere, brutally besieging Indians in order to take their lands and resources. In the process, they enslaved thousands of Indians, forcing them to work in gold, copper and silver mines, and were as adept at torture techniques as anyone else. It was the Euro-Americans' desire for Indian land that initiated wars. However, battles between Indians and Euro-Americans are often named after the tribe involved, even when the tribe did not instigate the fight. For example, encounters such as the Pequot War (1637), King Philip's War (1675), the Tuscarora War (1711), Natchez Revolt (1739), Pontiac's Rebellion (1763), Little Turtle's War (1790-94), the Creek Wars (1813-14), the Modoc War (1872-73), the Battle of the Little Big Horn (1876), the Bannock War (1878), the Ute War (1879), and the Apache Wars (1861-86) all give the

impression that Indians began the conflict, yet in reality, they fought to defend their lands, sovereignty and way of life from intruders.

On the other hand, outright massacres of Indian peoples by Euro-Americans have been improperly labeled as great military victories, most notably the Battle of the Washita (1868) and the Battle of Wounded Knee (1890). If one considers the magnitude of destruction of the Indians' populations and cultures at the hands of non-Indians, and that Indians fought Euro-Americans and each other usually to protect themselves, then Indians can't and shouldn't be considered more "warlike" than anyone else.

Many Euro-Americans also accused Indians of being treacherous. Those unfamiliar with tribal social structures assumed that chiefs had virtually dictatorial powers, when all they actually had were powers of persuasion. When Euro-Americans made a treaty or agreement with a chief or with one band or group of a tribe, they assumed it was binding on all. When other bands that were unaware of the treaty — and certainly not bound by it — violated it in some way, they and the treaty-making group were accused of treachery.

All these portrayals of Indian violence may really be a backhanded compliment, for it appears that many non-Indians respected the fighting abilities of Indians. One of the most admired traits of Indians is that they were often difficult to defeat, so when they were subdued, it enhanced their conquerers' reputation. Consider some of the Presidents in our history who were acclaimed as "Indian fighters:" George Washington, Andrew Jackson, William Henry Harrison. George Armstrong Custer aspired to the Presidency, and thought to advance his chances by killing Indians. As we know, he didn't reach his goal, but he has still been posthumously celebrated as a hero for fighting valiantly against savage heathens. Custer societies and Custer fan clubs in America, Europe and Australia have been formed, but it is beyond Indians' understanding as to why people celebrate an individual who is noteworthy solely for his efforts to destroy Indians, who was last in his class at West Point, was court-martialed, and who was intensely disliked by his own men (they called him "Iron Butt" and "Ringlets").

Among tribes in the Great Lakes area in the seventeenth century, warfare was part of a way of life, but not because Indians

craved fighting. To be sure, warriors were admired and respected in Indian cultures as they were in most others, and there was much brutal warfare. Considerable warfare came about for many of the socio-economic and political reasons that it occurs among other cultures, but some wars also occurred for reasons specific to only certain Indian cultures. Among the Iroquois for example, fighting was a necessity to protect their land base and it helped to hold their tribes together. A "mourning war" was periodically staged in order to take individuals from other tribes to replace their dead tribespeople, and killing some prisoners from tribes who had killed their own tribespeople helped ease the grief of relatives. After the arrival of Europeans and the establishment of the fur trade, the Iroquois engaged in rather violent competition with other tribes (like the Hurons) for the much-needed pelts and for coveted European items such as guns and ammunition. Indians took scalps of their enemies, but they did not invent scalping. The practice dates back to ancient Greece. In America, scalping was introduced by the Dutch who offered bounties for the heads of Indian men, women, and children. Transporting sacks of heads proved too cumbersome, so eventually only the scalps were taken. The Massachusetts and Pennsylvania colonies also offered bounty for Indian scalps.

Although Indians did fight each other prior to the European invasion, Euro-American expansion into Indian lands intensified inter-Indian conflicts. Tribes of the Great Plains admired their warriors, but found more impressive the ability to "count coup," that is, to touch an enemy with a coup stick, often a willow wand, without killing him or in some instances, her. Coup counters were rewarded with eagle feathers, and some war bonnets were made with the coup feathers, thus symbolizing the owner's bravery. Most bonnets were made from eagle feathers (and some with turkey feathers). Women did not wear war bonnets and only a few men did who belonged to tribes outside the Great Plains.

Another example of the so-called warlike Indian is the 19th century Shawnee leader, Tecumseh, who attempted to unite the tribes throughout the Old Northwest and in the Southeast in order to rid the area of intruders during the War of 1812. He was a great strategist, a shrewd commander, a natural orator who did not believe in torturing prisoners, and purported to be

handsome by European standards. He was, in short, a lot of things that Euro-Americans wanted to be. Contrast Tecumseh with his brother, Tenskwatawa, the Shawnee Prophet, who also wanted to repulse the invaders, but who advocated a more internal, spiritual way to deal with them— apparently not as admirable a solution, if one might judge by his lack of comparable acclaim among non-Indians. As time went by, embellished stories about the hero Tecumseh emerged, describing him as light in skin color and in love with Rebecca Galloway, a Euro-American woman. But this melodramatic relationship was doomed to failure because of their cultural differences. Tecumseh is still celebrated by non-Indians, while his less exciting brother is seen by many as little more than a one-eyed, epileptic alcoholic who transformed himself into a controversial prophet.

Sherry Smith, in her book *The View From Officer's Row*, discusses the admiration many Euro-American officers had for "fighting" Indians such as the Cheyennes, Nez Perces, Sioux and Apaches, and the disdain they had for the more "effeminate" (peaceful) tribesmen of the Northwest Coast. They assessed tribes by their fighting abilities, the same way they evaluated men of Euro-American society. Indeed, many of this country's leaders were renowned as "Indian fighters," and even today much ado is made about a candidate's "war history." The "fighting" Plains tribes with their headdresses and other trappings seem to provide the most admired of all the Indians' symbols, and even members of tribes that never wore headdresses wear them today to impress non-Indians.

It was not the mark of a great Indian warrior to kill as many enemies as possible, and other than the occasional deviants (who are present in all cultures), they did not eat, sleep and breathe to fight. While many Indians were apparently fond of fighting, they didn't fight all the time.

Recommended Readings:

Berthrong, Donald. *The Cheyenne and Arapahoe Ordeal* (Norman: University of Oklahoma, 1976).

Brown, Mark. *The Flight of the Nez Perce* (New York: Capricorn Books, 1971).

Connell, Evan S. *Son of the Morning Star*. (San Francisco: North Point Press, 1984).

Edmunds, R. David. *The Shawnee Prophet.*(Lincoln: University of Nebraska Press, 1984).

Idem. Tecumseh and the Quest for Indian Leadership. (Boston: Little, Brown and Company, 1984).

Forbes, Jack. *Apache, Navajo, and Spaniard* (Norman: University of Oklahoma Press, 1960).

Jennings, Francis. *The Ambiguous Iroquois Empire: The Covenant Chain Confederation of Indian Tribes with English Colonies From Its' Beginnings to the Lancaster Treaty of 1744.* (New York: Norton and Co., 1984).

Richter, Daniel K. "War and Culture: The Iroquois Experience." *William and Mary Quarterly* 40 (October 1983): 528-559.

Sandoz, Mari. *Cheyenne Autumn.* (New York: Hastings House, 1953).

Idem. Crazy Horse. (Lincoln: University of Nebraska Press, 1963).

Smith, Sherry L. *The View From Officer's Row: Army Perceptions of Western Indians.* (Tucson: University of Arizona Press, 1990).

Thrapp, Dan. *The Conquest of Apacheria.* (Norman: University of Oklahoma Press, 1967).

Worcester, Donald. *Apaches: Eagles of the Southwest.* (Norman: University of Oklahoma Press, 1979).

Jorge Rivero epitomizes the"war like"Indian image in the 1968 movie "Soldier Blue." *(Reprinted from The Movie Treasury: Great Western Movies, London: Octopus Books, 1974)*

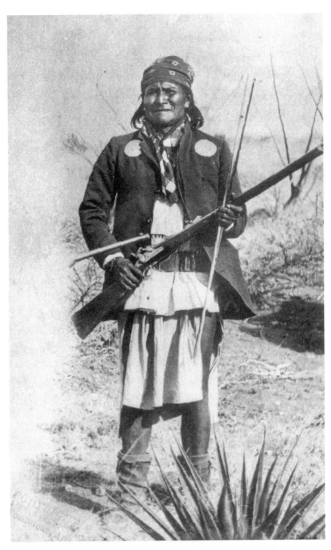

Goyanthlay (Geronimo), a Bedonkohe Apache, and two dozen Chirichuahua Apaches were chased throughout the Southwest by U.S. troops from 1881 to 1886. After surrendering with the understanding that they would not be separated from their families, the men were promptly boarded onto trains and shipped to Florida, where one-quarter of them died by 1890. The survivers were returned to Fort Sill, Indian Territory (now Oklahoma) in1894. Geronimo died there in 1909. (*Courtesy of Arizona Historical Society*).

STEREOTYPE
*Indians had nothing to contribute to Europeans
or to the growth of America*

REALITY
**The contributions of American Indians have changed
and enriched the world**

Various cultures contributed the many items that have shaped our world, but often contributions of American Indian peoples go unrecognized. Granted, the Europeans brought wheat, barley, rice, indigo, sugar, horses, cattle, sheep, hogs, pigeons, and chickens with them to the New World, but for the first 100 years after contact, their contributions that made the greatest impact were the diseases they brought, against which Indians had no immunity.

Indians and the New World had much to offer the newcomers. Many of their foods changed the diet of the entire world, particularly corn, white and sweet potatoes, manioc, squashes, pumpkins, tomatoes, strawberries, maple sugar, raspberries, avocados, cacao (chocolate), a variety of beans, and chile peppers, to name a few foods. Many exotic plant foods, such as a buttery-tasting tuber and a fruit that had a combination flavor of banana, papaya and pineapple, were lost after contact because the Spaniards forced the South Americans to grow barley and wheat instead. Partly because of the introduction of corn, manioc and potatoes to the Old World, between 1650 and 1850 the population of the world doubled, then in the next 100 years it doubled again. Indeed, of the rich diversity of foods we enjoy today, almost 60% originally came from the Americas.

Hundreds of herbs used by Indians have also contributed to modern medicine. American Indians enlightened the first European invaders with their cures for amoebic dysentery, scurvy, constipation, intestinal worms, headaches, flesh wounds, and myriad other diseases.

Aspects of traditional tribal religions, such as emphasis on the relatededness and harmony between man and nature, and

the variety of ceremonies tribes practiced to ensure such harmony, are used by non-Indians in attempts to create balance and happiness in their own lives. Unfortunately, these traditional philosophical beliefs and ceremonies are often appropriated by individuals who pose as Indian "spiritual leaders" eager to profit from the image of "Indian as mystical environmentalist."

Indians contributed to the success of Europeans in the New World by teaching them survival skills, trading with them, allying with them during wars, serving as scouts for their armies, mining gold, silver, and copper for them at the literal cost of their lives and limbs, showing them routes through "uncharted" territories and of course, ceding them land and all the resources that went with it.

The American Founding Fathers (such as Thomas Jefferson, James Madison, and Benjamin Franklin) who drew up the U.S. Constitution were influenced not only by European writers such as Locke, Rousseau and Montesquieu, as well as ideas found in the Magna Carta and the Greek and Roman Empires, but also by the the powerful, well-organized Haudenosaunee (Iroquois) Kaianerekowa (Great Law of Peace). The Constitution framers therefore adopted certain aspects of the Iroquois Confederacy in forming our federal system, such as impeachment, equal representation of nations (states), checks and balances, and the concepts of freedom, peace and democracy.

Indians have fought for the United States in every single war this country (or its colonists) have been involved in: the colonial wars, the Revolutionary War (though of course many Indians fought against the American colonists during the colonial period), the War of 1812, and the Civil War. More recently, 8,000 Indians fought in World War I; 25,000 fought in World War II and representatives of several tribes, most notably Navajos, Choctaws, Comanches, and some Apaches, served as Code Talkers; 41,000 Indians served in Vietnam, and 24,000 served in Operation Desert Storm.

One of every four Indian males is a veteran, and almost half of the Indian tribal leaders are veterans. Indians have served and still serve as educators, writers, politicians, physicians, social workers, scientists, counselors, lawyers, law enforcement officers, mechanics, and athletes, to name only a few professions. Indians are active in every segment of this society and are invaluable

contributors to the growth and continuity of U.S. society. Non-Indian academics writing about Indians have received tenure, raises, grants, awards and promotions for their work, while Indians often gain nothing. Euro-American business men and women have used Indian images to make profits, as have towns with Indian populations

Indians have also contributed place names of states, towns, rivers, mountains, automobiles, clothing, and sports teams. They have produced jewelry, exquisite pottery, baskets, blankets, sculptures and paintings, and have created award-winning poetry, novels, and music. Their images have served the Boy Scouts and men's fraternal organizations such as the Order of the Red Men, and have been featured as entertainment in a thousand movies, television shows and romance novels.

Examples of commonly known Indian place names:

States: Alabama, Alaska, Arizona, Arkansas, Connecticut, Missouri, Kansas, Dakota, Erie, Idaho, Illinois, Indiana, Iowa, Kansas, Kentucky, New Mexico, Michigan, Minnesota, Mississippi, Missouri, Nebraska, Ohio, Oregon, Tennessee, Texas, Utah, Wyoming

Cities and towns: Amagansett, Anadarko, Anchorage, Atoka, Bemidji, Biloxi, Cahokia, Chesapeake, Chautauqua, Chattanooga, Claremore, Council Bluffs, Kayenta, Miami, Minneapolis, Mobile, Muskogee, Nacogdoches, Natchez, Omaha, Oneida, Oswego, Peoria, Roanoke, Sandusky, Saratoga, Seattle, Spokane, Tacoma, Tallahassee, Tampa, Taos, Topeka, Tucson, Tucuncari, Tulsa, Waco, Walla Walla, Waxahachie, Wichita, Yakima, Yuma

Rivers: Apalachicola, Arostook, Chattahoochee, Iditarod, Klamath, Maumee, Missouri, Niagra, Niobrara, Oswego, Pecos, Roanoke, Sandusky, Tippecanoe, Tombigbee, Wabash, Washita, Yukon

Islands: Chappaquiddick, Kodiak, Manhattan, Nantucket

Mountains: Allegheny, Appalachian, Black Hills, Klamath, Shasta, Shenandoah, Spokane, Timpahute

Automobiles, Pontiac, Cherokee Jeep, Navajo, Winnebago

Clothes: Cherokee, Oshkosh

Examples of Indian artists:

Paint and Sculpture: Paul Apodaca (Navajo), Michael Chiago (Tohono O'Odham), Charles Edenshaw (Haida), Harry Fonseca

(Maidu), Carl N, Groman (Navajo), R.C. Gorman (Navajo), Allan Houser (Chiricahua Apache), Osacr Howe (Yankton Sioux), Linda Lomahaftewa (Hopi/Choctaw), Solomon McCombs (Muscogee), Norval Morrisseau (Ojibway), Daphne Ogjig (Potawatomi), Kevin Redstar (Crow), William Ronald Reid (Haida), Fritz Scholder (Luiseno), Diosa Summers Fitsgerald (Mississippi Choctaw), Gerald Tailfeathers (Blackfoot), Roger Tsabetsye (Zuni), Pablita Velarde (Santa Clara).

Basketry and pottery: Luisa Keyser (Washo), Maria Marinez (San Ildefonso), Nampeyo (Hopi/Tewa), Juan Tafoya (San Ildefonso), Elizabeth Naranjo (Santa Clara).

Music and Dance: Kevin Locke (Lakota), R. Carlos Nakai (Navajo/Ute), Buffy Sainte-Marie (Cree).

Literature: Paula Gunn Allen (Laguna/Sioux), Beth Brant (Mohawk), Joseph Bruchac (Abenaki), Barney Furman Bush (Shawnee/Cayuga), Elizabeth Cook-Lynn (Sioux), Michael Dorris (Modoc), Louise Erdrich (Turtle Mountain Chippewa), Joy Harjo (Muscogee), Linda Hogan (Chickasaw), E. Pauline Johnson (Mohawk), E. Scott Momaday (Kiowa), Carlos Montezuma (Yavapai), Duane Niatum (Klallam), Simon Ortiz (Acoma), Alexander Posey (Muscogee), Carter Revard (Osage), John Rollin Ridge (Cherokee), Wendy Rose (Hopi/Me-wuk), Leslie Marmon Silko (Laguna), Mary Tallmountain (Athapascan), Gerald R. Vizenor (Chippewa).

Recommended Readings:

Richard Aquila, *The Iroquois Restoration* (Detroit: Wayne State Universitry Press, 1983).

Duane Champagne *Native America: Portrait of the Peoples* (Detroit: Visible Ink, 1994; pp. 549-758).

Colonnese, Tom and Louis Owens, comps. *American Indian Novelists: An Annotated Critical Bibliography* (New York: Garland Press, 1985).

Crosby, Alfred. *The Columbian Exchange* (Westport: Greenwood Press, 1971).

Dunlay, Thomas W. *Wolves for the Blue Soldiers: Indian Scouts and Auxiliaries with the United States Army, 1860-90* (Lincoln: University of Nebraska Press, 1982).

Grinde, Donald A. and Bruce E. Johansen. *Exemplar of Liberty: Native Americans and the Evolution of Democracy* (Los Angeles: American Indian Studies Center, 1991).

These seventeen *Comanche code-talkers* were honored by France in 1989, but the U.S. government has yet to recognize their efforts during World War II. (*Courtesy of Comanche Nation of Oklahoma*).

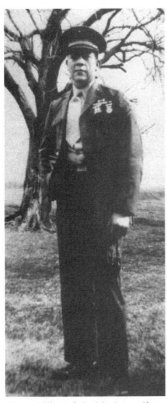

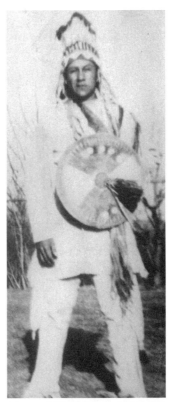

Henry Mihesuah in Marine uniform during World War II. He was one of the 25,000 Indians who served in the War. (Courtesy of Henry Mihesuah).

Henry Mihesuah, a fullblood Comanche as a teenager c1940, dressed in his grandfather's regalia, including his shield. *(Courtesy of Henry Mihesuah)*

Johansen, Bruce E. *Forgotten Founders* (Ipswich, Massachusetts: Gambit Inc., 1982).

Leitch, Wright J. *The Only Land They Knew: The Tragic Story of the American Indians in the Old South* (New York: The Free Press, 1981).

Littlefield, Daniel L. *A Bibliography of Native American Writers, 1772-1924.* (Metuchen: Scarecrow Press, 1981).

Idem. A Bibliography of Native American Writers, 1772-1924: A Supplement. (Metuchen: Scarecrow Press, 1985).

Ruoff, A. LaVonne Brown. *American Indian Literatures: An Introduction, Bibliographic Review, and Selected Bibliography* (New York: MLA, 1990).

Rydjord, John. *Indian Place Names: Their Origins, Evolution, and Meanings* (Norman: University of Oklahoma Press, 1968).

Van Kirk, Sylvia. *Many Tender Ties: Women in Fur-Trade Society, 1670-1870.* (Norman: University of Oklahoma Press, 1983).

Vogel, Virgil J. *American Indian Medicine.* (New York: Ballantine Books, 1973).

Weatherford, Jack. *Indian Givers: How the Indians of the Americas Transformed the World* (New York: Crown Publishers, Inc., 1988).

STEREOTYPE
Indian tribes did not value or empower women

REALITY
Indian women often wielded considerable power within their tribes

Because of the influence of television, movies and literature, non-Indian Americans usually think of Indian women in either of two contradictory ways: 1) they are ugly, dirty, subservient, abused "squaws" who loved to torture white men; or 2) they are beautiful, exotic "Princesses," often Chiefs' daughters, usually willing to leave their people to marry dashing Europeans.

The European conception of royalty and its nomenclature never existed in any tribe but rather was imposed on them by Europeans, who were accustomed to notions of hereditary royalty. The Europeans had difficulty understanding tribal politics and organization, and applied European titles to tribal leaders in order to simplify and clarify, in their own terms, the relative Indian power relationships. For example, Metacom, the leader of the Wampanoags in the 1670s, was renamed "King Philip." Pocahontas was the daughter of Wahunsonacock, chief of the Powhatan confederacy, but she was not a princess. Because Princesses are supposed to be the daughters of Kings and are beautiful and refined — at least in the imagination and in Walt Disney movies — countless Americans claim to have an Indian Princess for a grandmother.

The value accorded their women by Indian cultures has been vastly underrated — historically and today. Women did not and do not play a less significant role than men, and just like the women of other cultures, they had their own individual personalities. Though it was Indian women who held their societies together, most literature focuses upon males as leaders, and women as followers. Tribes such as the Cherokees and Iroquois were matrilineal and matrilocal societies, that is, the husband-father role was to sire children, who belonged to their

This photo of *"half breed" Jennifer Jones* (a real-life non-Indian) dancing in 1946 movie "Duel in the Sun," gives the false impression that Indian women looked like dark-skinned white women. *(Reprinted from Great Western Movies)*

mother's clan, lived in their mother's family's home and inherited her property. Chiefs were from the women's side of the family. In many tribes, women gave advice to the men prior to the council meetings, if they did not actually sit in the meeting. A group of elder females among the Iroquois tribes, or Matrons, chose tribal leaders. Often, women dictated the fate of prisoners, and a few fought in battles. Even male-centered tribes (patrilocal, patrilinear) held women in high esteem. Among the "fierce" Apaches, for example, women quietly exerted a powerful influence by advising their husbands in private; the men then took "their" opinions to council.

Like many other aspects of Indian culture, the value accorded Indian women by Indian tribes has been difficult to assess because the filtration processes of European consciousness has often projected European prejudices against their own women onto the relations of Indian men and women. One reason why Indian women have been ignored is that early documentation of tribes was written by Europeans, and as far as they were concerned, males were the dominant figures within any society. Even in the late 1800s, when Indian women such as Belle Cobb (Cherokee) and Susan LaFlesche (Omaha) earned medical degrees and others graduated from colleges and universities around the country, they were ignored by writers in favor of the seemingly more-important males. Indeed, the majority of Indian biographies have been written about Indian men and it has only been in the last twenty years that writers have taken serious interest in Indian women.

In movies and on television, roles of Indian men have been glorified while women's roles are ignored. Hunting buffalo, elk, deer and bears, fighting, tracking and dealing with whites is more exciting than the less glamorous, more tedious, but no less skilled or socially valuable array of women's jobs such as skinning, butchering, tanning and preserving the flesh in addition to cooking, cleaning, beading, weaving, making clothes, building homes and taking care of the children. Indian women were also farmers, healers and traders. These duties gave substantial power within the various tribal structures to women, but that aspect is often overlooked or not understood.

Contact with Europeans, however, dramatically altered Indian women's roles within their tribal settings. Shortly after

contact, women found themselves in less influential political, economic, religious, and social positions, and in almost every sphere women were forced to become subservient to men, both Indian and non-Indian. For example, among Iroquois tribes, with the establishment of reservations in the late 18th century, women's political status changed. Colonial powers refused to discuss anything with women and they convinced the Indian men to ignore women's advice. In the early 19th century, the Iroquois Matron-appointed leader system was gone, replaced by a system of elected representatives. Only men, however, were allowed to vote.

Colonialism also weakened the economic power of women. Because the end of tribal warfare diminished the men's role, Canadian and American powers persuaded Indian men to farm, thus displacing the women who previously controlled the production and distribution of agricultural products. Among the Cherokees, those European men who married Indian women demanded that their family adhere to their values, which included a market society in which property-owning males dominated production and politics. Among Plains tribes, men completely controlled trade and women became laborers for a market to which they had no access. Women became commodities and were valued primarily for their ability to work.

Missionaries created havoc with men's and women's traditional tribal roles. European missionaries introduced the notion that God was male and that women were inferior to men. This idea was counter to most traditional tribes' creation stories. Many tribes, such as the Navajo, Cherokee, Lakota and various Iroquois, Apache and Pueblo tribes believe that female deities played primary roles in the creation and continuity of their peoples. Females are believed to provide sustenance and protection, and therefore command respect. Many people from the Judeo-Christian tradition, however, compare women unfavorably to Eve, who conspired with a serpent to expose man to evil. Only a few tribal members needed to alter their traditional views in favor of Christianity in order to render women's place in tribal society less important. Many medicine women and female spiritual leaders began to lose favor with the tribe and fewer women were allowed to pursue religious roles.

The main social change among tribes was the shift from matriarchal to patriarchal societies. The Cherokees are a prime example of such change. In 1808, a Council of Headmen officially recognized the patriarchal family as the norm, and a police force was created in order to "give protection to children as heirs to their father's property and to the *widow's* share" (italics mine). Two years later, the Council abolished the traditional act of blood vengeance (whereby the family of a victim of crime dispensed justice to the accused) and replaced it with the tribal court system. Previously, women determined the fate of the guilty party. Among many tribes there was a sharp increase in wife abuse that continues today. Many Indians believe such abuse is in part the result of frustration over the loss of traditional gender roles.

Fortunately, many Indians still believe in the importance of women within their tribes and more women are asserting their beliefs and talents in an effort to ensure tribal survival. Indian women are beginning to write about themselves and their ancestors, thus contributing a much-needed Indian female perspective on history and culture. Indian women today graduate from universities at a higher rate than men, and they hold the same jobs that men do, including in the Armed Forces. National Indian women's organizations have been formed, such as Women of All Red Nations, Inuit Women's Association, White Buffalo Calf Society, and the Native Women's Association of Canada. Over half of the tribes in the U.S. have women on their councils and some tribes have women as their leaders.

Recommended Readings:

Albers, Patricia and Beatrice Medicine. *The Hidden Half: Studies of Plains Indian Women* (Washington, D.C.: University Press of America, 1983).

Allen, Paula Gunn. *The Sacred Hoop: Recovering the Feminine in American Indian Traditions* (Boston: Beacon Press, 1986).

Bataille, Gretchen, and Kathleen Mullen Sands. *American Indian Women: Telling Their Lives*. Lincoln: University of Nebraska Press, 1984.

Bataille, Gretchen, ed. *Native American Women* (Hamden, CT: Garland Publishing Co., 1992).

Green, Rayna. "The Pocahontas Perplex: The Image of Indian Women in American Culture," *Massachusetts Review* 16 (1975): 698-714

Idem. *Native American Women: A Contextual Bibliography* (Bloomington: Indiana University Press, 1983).

Idem. Women in American Indian Society. (New York: Chelsea House Publishers, 1992).

Perdue, Theda. "The Traditional Status of Cherokee Women," *Furman Studies* (1980): 19-25.

Trexler, Richard C. *Sex and Conquest: Gendered Violence, Political Order, and the European Conquest of the Americas* (Ithaca, N.Y.: Cornell UniversityPress, 1996).

Also see readings in the sample syllabus, "American Indian Women in History," in Appendix D.

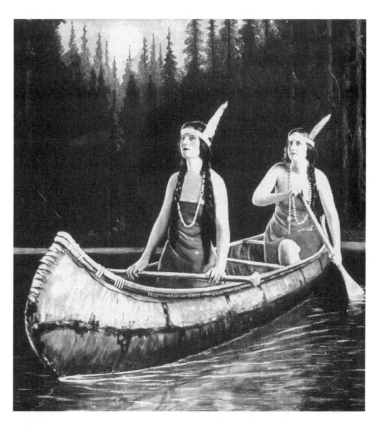

Women in a canoe: Artists often paint their subjects according to the standards of their time. This early twentieth century product depicts Indian women almost as flappers, with plucked eye-brows, thin red lips, and a long necklace. *(Courtesy of Henry Mihesuah).*

STEREOTYPE
Indians have no religion

REALITY
Indians are deeply religious
Each tribe has its own religion

When missionaries and other Europeans encountered Indians, they were convinced that because the tribes were not Christians, they could not possibly have religions of their own, only superstitions. They either were Christians or they were heathens. Being a Christian was one of the requisites to being civilized, and the Spanish, English, French, Dutch and Russians all sent missionaries who attempted to convert Indians to what they believed to be the "true religion." While missionaries did indeed manage to "save some souls," most Indians preferred their own religions and were determined to practice them no matter the cost.

Many missionaries were intolerant of Indian religions. Around 1540, Spanish missionaries made their way to the Pueblo tribes of the Southwest and proceeded to build missions and forts. When they attempted to convert Indians to Catholicism, they also tried to banish the tribes' traditional religions, labeling them uncivilized and heathenish. Although some Indians integrated certain aspects of Catholicism into their own religions, that was not sufficient for the Spanish. Sacred corn and masks were destroyed, and Pueblo priests were physically punished or killed for conducting traditional tribal ceremonies. Missionaries did not understand the tenacity of the Indians' spirituality, and their abuse led to the Pueblo Revolt of 1680. Although Spain dominated the Southwest until 1810, the tribes still retained their traditional religions, although some incorporated Catholic ceremonies and still practice them.

In the late 1880s, Indian religious ceremonies were outlawed in the United States. Indian children that were forced to attend federal boarding schools were taught that their religions were

barbarous and some were even taken from their families to be adopted by Euro-American families. But Indians continued to practice their ceremonies in private. It was not until the American Indian Freedom of Religion Act of 1978 that the law was appealed. But Indians still do not enjoy the religious freedom guaranteed by the First Amendment of the Constitution. Many states do not tolerate such Indian religions as the Native American Church, perhaps because of its use of peyote. Indians in many prisons and in schools are not allowed to wear their hair long or to participate in sweat lodge ceremonies ("sweats"), and there are few laws to protect Indian grave sites and shrines.

Many missionaries and other non-Indians fail to understand that Indians were and are deeply religious. Indian spirituality is not just an oversimplified "love of nature and all living things," as some non-Indians interpret it to be. Indian spirituality permeates all aspects of life: physical, emotional and social. The various aspects of one's life, including religion, work, warfare, social activities, education, eating and playing are not compartmentalized to a daily or weekly schedule. All aspects are closely intertwined, and it is not easy to explain or understand. Indian religions tend to be only superficially understood — or totally misunderstood — by non-Indians. Each tribe has its own religious traditions, with ceremonies to mark the seasons, to give thanks, to ask for prosperous hunting and growing, in addition to specific ways to sing, dance, and to bury their dead. Like other aspects of Indians' cultures, their religions cannot be generalized.

Despite their persecution, Indian religious beliefs have survived and thousands of Indians still practice their traditional ceremonies. It is true that many Indians have converted to Christianity and numerous other faiths. Many have become priests, ministers, and even rabbis. Not all Indians are knowledgeable about their tribes' particular traditional religion. Many have been raised as Christians and know little, if anything, about their tribes' beliefs. In addition, not all Indians attend sweats (some have never been in one) and not all Indians carry feathers or medicine bundles.

It should be noted that there are scores of books written about Indian religions, and many of these books are available in every bookstore. The vast majority are written by non-Indians. Many of these popular books were written without tribal permission or

tribal input, and their authors are often incorrect in their interpretations. Those books that contain inaccuracies will remain uncorrected, for most Indians do not want to point out the errors in an attempt to keep their religions private. It is, therefore, up to the tribes to recommend books on their specific religions.

Recommended Readings:

Hirschfelder, Arlene, and Paulette Molin. *The Encyclopedia of Native American Religions* (New York: Facts on File, 1992).

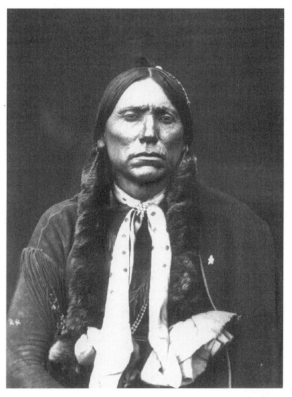

Quanah Parker (c1852-1911) was the son of Comanche Peta Nocona and a white woman, Cynthia Ann Parker. He became Chief of the Comanches and was instrumental in spreading the word of the Native American Church. *(Courtesy Arizona Historical Society)*

STEREOTYPE

Indians welcome outsiders to study and participate in their religious ceremonies

REALITY

Indians often practice their religions secretly and want outsiders to respect their desire for privacy

Hundreds of books and articles have been written about American Indian religions. Yet relatively few have been written by Indians. There is a simple reason for this: most Indians don't want even the basic nuances of their tribal religions to be aired for public scrutiny. Unless they are converts to those religions possessing evangelical zeal, Indians do not sally from door-to-door in search of converts to their faith. Nor do Indians presume an intellectual right to intrude on church or synagogue services in order to observe and document the rituals of faiths other than their own. Many non-Indians, however, have appeared to be almost desperate to learn about tribal religions and even to participate in their ceremonies. Some may be genuinely seeking to fill a void in their lives, but many come to chronicle ceremonies, dances and songs in order to write a book or make a film. In one year alone, four European students wrote to me to ask whether they could come to Arizona in order to study "Indian religion" (Hopi or Navajo, they did not care which) for their theses. Historically and today, non-Indians have written about Indian religions, and have revealed certain aspects that shouldn't be told. It's little wonder that Indians are closed-mouthed about their spirituality.

Non-Indians claiming to be "spiritual leaders," "healers," and "medicine men and women" abound in this country, and these "crystal twinkies" (as a former Hopi student likes to call them) make a pretty decent living at deceiving the public. Sadly, some Indians who aren't tribally-recognized spiritual leaders have learned that holding "religious seminars," sweats and sundances for non-Indians is a quick way to make some cash. One individual

in Flagstaff holds sweats for university classes (at $25 a head), and even signs "pipe-carrier" after his name, like a PhD. Throughout 1991, the *Lakota Times* newspaper (now called *Indian Country Today*) investigated self-proclaimed medicine men and women, and revealed that their organizations, such as the American Indian Church (not to be confused with Native American Church), Medicine Wheel Circle/Gathering, Pan American Indian Association, Split Feather Tribal Council, Sun Bear and the Bear Tribe Medicine Society as well as Lynn Andrews, and Harley "Swiftdeer" Reagan and the "Deer Tribe," are all bogus Indian groups or spiritual leaders that fleece naive non-Indians who want to learn about Indian spirituality. All of these New Age organizations along with phony medicine people not only insult Indians, but they also give the false impression that Indians are open about their religions and will allow outsiders into their fold for a price.

While some Indians will tell outsiders anything they want to know about their tribes' religions, most view inquisitive non-Indians as nothing more than profit-makers or curiosity seekers. Just because one Indian will discuss religion does not mean the rest of the tribe sanctions it. In fact, most Indians are intensely private about their religions and will often let non-Indians believe anything they want to without correcting them. Spirituality is not something to discuss in casual conversation. Because of the history of persecution of Indian religions, the fear of being ridiculed, or the potential for loss of spiritual power, most Indians will not discuss their religion and view questions about it as intrusive.

Songs, dances, sweats, music, drumming and ceremonies are usually not to be recorded or video-taped, yet it never fails that some observer secretly does just that. Many non-Indians attempt to imitate certain ceremonies and religious paraphernalia, but without proper guidance and commitment they often blunder around in error, such as singing songs reserved for certain families or individuals. One example of non-Indians performing sacred Indian dances are the "Smokis" of Prescott, Arizona, an organization composed of affluent Euro-American businessmen who perform a facsimile of the Hopi snake dance for ignorant tourists. Hobbyists in Europe, most notably in Germany, also re-enact tribal ceremonial dances. Not only is this unethical, it is

71

sacrilegious, for the sacred dances and ceremonies of any tribe are not for public viewing—unless the tribe wants them to be. Non-Indians appear to feel free to toy with and trivialize Indian religions in a manner that would be seen as highly disturbing, if practiced against Christianity, Judaism or Islam.

The desecration of Indian burial sites and shrines that occurs throughout the country also has a profound effect upon Indian spirituality. American Indians' remains and sacred objects are displayed in museums and on coffee tables, as if the remains were not those of actual people but were only archaeological artifacts. Sacred objects are treated as superannuated relics, not as related to living, sustaining belief systems. Pot hunters and grave-robbers illegally destroy hundreds of burials each year, and they steal burial items and pottery to sell on the black market. An estimated 80 percent of sacred sites in the Southwest have been looted, and Robert Mallouf, the Texas State Archaeologist, believes that almost all Indian burials in his state have been disturbed by pot hunters. Many archaeologists also take these items, excusing this desecration on the grounds that they have taken them to study, much to the distress of the tribes who want the remains of their ancestors returned. Most large universities and museums have collections of thousands of remains and sacred objects, but at least some museums, like the Smithsonian Institution in Washington, D.C., are beginning to repatriate items to tribes.

Fortunately, many states have enacted laws to protect Indian burials on public and private property. In 1990, the Native American Graves Protection and Repatriation Act (N.A.G.P.R.A.) was signed into law by President Bush in order to protect burials, sacred objects, and funerary objects on federal and tribal lands, in addition to allowing American Indians and Native Hawaiians a strong voice in deciding the fate of human remains and sacred objects held by museums and federal agencies. In an effort to keep tourists and pot hunters from stealing artifacts, the location of numerous ruins in Arizona, New Mexico, and California may be removed from road maps and guide books.

Tribes are attempting to prevent interference in their religious activities. For instance, because of disrespect shown during sacred Hopi dances, that tribe has banned all non-Indians from attending its Snake Dance. Hopis also have successfully

negotiated the return of a sacred tribal mask from a New York City art show, and the Zunis have recovered almost all of their War Gods from museums. Because of the lack of sensitivity many scholars have demonstrated while studying Indians and their cultures, various tribes are regulating the type of research permitted on their people and culture by monitoring forays onto their reservations and by contacting publishing houses about what they do and do not want published.

In regard to researching Indian religions, permission to interview tribal members and to study and observe Indian religious ceremonies should always be requested from the tribal political and religious leaders, and the researcher should not take offense if the answer is "no".

Recommended Readings:

American Indian Culture and Research Journal special edition: Repatriation of American Indian Remains, vol. 16 (1992).

Arizona State Law Journal special issue: Symposium on The Native American Protection and Repatriation Act of 1990 and State Repatriation-Related Legislation, vol. 24 (Spring 1992).

Indian Country Today. 1920 Lombardy Dr., Rapid City, SD, 57701.

Messenger, Phyllis Mauch. *The Ethics of Collecting Cultural Property: Whose Culture? Whose Property?* (Albuquerque: University of New Mexico Press, 1990).

Mihesuah, Devon A. "Suggested Research Guidelines for Institutions With Scholars Who Study American Indians." *American Indian Culture and Research Journal* 17 (Fall 1993): 131-139

Idem, ed. American Indian Quarterly special issue: "Repatriation of American Indian Skeletal Remains and Sacred Cultural Objects" vol. 20, #2 (1966).

STEREOTYPE
Indians are a vanished race

REALITY
There are 2.1 million United States Indians today

It has been recently estimated by sociologist and demographer Russell Thornton that when Christopher Columbus stumbled upon the coast of San Salvador in 1492, there were approximately seven million individuals living in North America — five million in the area we know today as the United States. In the following 100 years, because of diseases, warfare, displacement, intermarriage and genocide, the Indian population in North America dropped to three million. By 1880, Indians numbered 600,000 and by 1900, their population was at its lowest: 250,000. In this same period, the non-Indian population in the United States increased from five million in 1800 to 75 million in 1900.

Well before the year 1900, non-Indians thought the Indians were on their way to extinction. Their populations were declining, and their land base had decreased from encompassing the entire United States to 156 million acres in 1881, and to 48 million acres in 1934. When the "vanishing red man" theory did not prove to be true, Euro-Americans still believed that Indians would forget their traditions and assimilate into the dominant Euro-american culture. Concerned for their survival, some Indians did adopt the ways of Euro-Americans, but many more continued to practice their traditions as best they could. In 1928, it was acknowledged belatedly by the government that Indians suffered from severe health problems, high unemployment, and extreme poverty. Women have been sterilized without their consent, children have been taken from their homes to be placed in boarding schools or with Euro-American families, religions have been outlawed and health services promised to Indians by the federal government have been inadequate. Today, there are anti-Indian groups such as Enough is Enough, Totally Equal Americans (TEA) and Equal Rights for Everyone (ERFE) that

attempt to abrogate treaty rights and even to terminate the tribes. The organization, Stop Treaty Abuse (STA), has produced "Treaty Beer," donating profits to politicians who are in favor of renouncing treaties.

Despite the severe social, political, economic and religious disruptions, in addition to the mental effects that go with it, the Indian population has increased and continues to grow, partly because of health care, vaccinations, increased immunity to diseases, a higher birth rate than death rate, and the option of self-identity as "Indian" on censuses. In the 1960s, the reservation Indian populations began increasing twice as fast as the American population. In 1994, there were 2.1 million Indians, Aleuts, and Inuits in the United States.

Some Indians are bicultural and bilingual. Many are mixed-bloods with a modicum of Indian blood and have no knowledge of or interest in their tribal language, religion or culture. But despite the assimilation of many Indians into mainstream American society, tribal traditions and ties remain strong among many, and it appears that they will remain strong through the generations.

Recommended Readings:

Denevan, William M. *The Native Population of the Americas in 1492* (Madison: University of Wisconsin Press, 1976).

Dobyns, Henry F. *Native American Historical Demography: A Critical Bibliography* (Bloomington: Indianan University Press, 1976).

Thornton, Russell. *American Indian Holocaust and Survival: A Population History Since 1492* (Norman: University of Oklahoma Press, 1987).

STEREOTYPE

Indians are confined to reservations, live in tipis,
wear braids, and ride horses

REALITY

There is nothing that confines Indians to reservations
Few wear braids and ride horses
Fewer still own tipis

Many foreigners and even Americans believe that Indians are required to remain on reservations, and that they live in tipis and ride horses. They also believe that all Indians wear braids, beadwork, turquoise and ribbon shirts. Some Indians do wear these things, but others wear their hair in as many different styles as other Americans. Not all Indians like to wear turquoise, silver or shirts with ribbons.

The 286 reservations are home to at least that many tribes (some reservations have more than one tribe), and have a population totalling approximately 950,000 Indians and non-Indians. The largest is the Navajo reservation comprised of almost 16 million acres in Arizona, Utah and New Mexico. Smaller reservations range in size from 1,000 acres to less than 100 acres. Because of intermarriage and employment, an additional 370,000 or so non-Indians live on reservations. Indians that live on reservations are free to come and go as they please. A good number of Indians — at least one million — do not live on reservations and never have. Many were born in urban hospitals and have always lived in urban areas. Some members of tribes whose tribal governments are situated on the reservations live in urban areas and even in other countries. Some return to the reservation for ceremonies or to visit relatives and friends, while others never return.

During the mid-to-late nineteenth century, reservations were quite similar to prison camps, and those tribes assigned to reservations were supposed to remain on them. In fact, Adolph Hitler so admired U.S. reservation policy (forcing Indians into

restricted territories where incidentally, many died of starvation and exposure) that he used it as a model for his genocidal plans against the Jews. From the 1860s through the 1880s, United States policies included settling many tribes on tracts of land that at the time appeared worthless, and were out of the way of Euro-American expansion. Presumably, the Indians would become "civilized" (according to the Euro-American definition of "civilized") on isolated reservations. By the 1880s, the tribes across the U.S. were for the most part subdued, and were confined to the reservations where alcoholism, disease and poverty raged. Because of their separation from traditional homelands and their loss of self-determination, reservation Indians despaired. Fortunately, some tribes were at least able to retain a portion of their traditional lands on their respective reservations by treaty.

Today, reservations are home to many Indians; it is where their families, friends, culture and traditional lands are. Some feel they are sheltered from prejudice on reservations, where they find acceptance among their own people. Some individuals on reservations live in houses of different sizes equipped with various amenities such as microwaves, televisions, stereos and satellite dishes, while others lack even the basic living necessities like running water and a solid roof. A handful may live in tipis for a part of the year because they want to, but tipis are not the typical dwelling. Members of the Native American Church also utilize tipis for their religious ceremonies. Some ride horses to herd cattle and sheep, or ride for recreation if they can afford it, but most Indians on reservations and in urban areas do not own horses.

Recommended Readings:

Danziger, Edmund J. *Indians and Bureaucrats: Administering the Reservation Policy During the Civil War* (Urbana: University of Illinois Press, 1974).

Fritz, Henry. *The Move for Indian Assimilation* (Philadelphia: University of Pennsylvania Press, 1963).

Hagan, William T. *Indian Police and Judges: Experiments in Acculturation and Control* (New Haven: Yale University Press, 1966).

Idem. United States-Comanche Relations: The Reservation Years (New Haven: Yale University Press, 1976).

Jackson, Helen Hunt. *A Century of Dishonor* (New York: Harper and Bros., 1881).

Mardock, Robert. *The Reformers and the Indians* (Columbia: University of Missouri Press, 1971).

Priest, Loring. *Uncle Sam's Stepchildren* (New York: Octagon Books, 1942).

Prucha, Francis Paul. *American Indian Policy in Crisis* (Norman: University of Oklahoma Press, 1976).

Thompson, Gerald. *The Army and the Navajo* (Tucson: University of Arizona Press, 1976).

Toland, John. *Adolph Hitler vol. 1* (Garden City, New York: Doubleday and Co., Inc.,1976).

Utley, Robert. *The Last Days of the Sioux Nation* (New Haven: Yale University Press, 1963).

Wissler, Clark. *Indian Calvacade, Red Man's Reservations* (New York: MacMillan Co., 1971).

Navajo mannequin: This sad and deformed-looking mannequin dressed as a Navajo man and all the others that adorn entrances to tourist shops give the impression that Indians were "hangers around the fort," waiting for handouts. *(Photo by Devon Mihesuah)*

STEREOTYPE
Indians have no reason to be unpatriotic

REALITY
Most American patriotism is the celebration of Euro-American history and interests. Euro-Americans' behavior and policies towards Indians have been brutal throughout American history.

Non-Indians often do not understand why many Indians will not celebrate Thanksgiving, Columbus Day, the Fourth of July, George Washington's Birthday or the other American holidays. Some become downright hostile when Indians prefer to use these timemarks as opportunities to remind America of what "democracy" and "freedom" have done for them. While many Indians do celebrate these hallowed events nonetheless, many do not, with perhaps the exception of Veterans' Day.

Indians can provide plenty of documentation to prove injustices they and their ancestors have suffered in the process of the founding of the United States. But in keeping with American denial of many other historical realities, it is not surprising that non-Indians do not like to hear of the vast numbers of Indians killed in the 500 years following the arrival of Columbus, nor do they like to be reminded of the problems Indians face today. Many non-Indians feel that the guilt of their ancestors is not their own, and that, despite the problems their ancestors faced in the past, Indians should stop complaining and work hard like all non-Indian Americans are presumed to do. This is the same thing Euro-Americans tell the African-American descendants of the African population they imported and enslaved. But if one considers the history of Indian-Euro-American relations, then celebrating the aforementioned holidays is tantamount to celebrating the Massacres at Sand Creek, Wounded Knee, Gnadenhutten, the Washita, the mass hanging of the Santee Sioux, and numerous other conflicts that are thoroughly chronicled. Many Indians believe that honoring

Columbus on Columbus Day is akin to celebrating a "Hitler Day."

So what are some of the reasons why Indians do not celebrate the same events as non-Indians? What is the situation today among Indians? Many of the problems Indians must deal with are directly related to the Bureau of Indian Affairs (B.I.A.). In 1824, the B.I.A. (known then as the Indian Office) was created within the War Department, and was transferred to the Department of the Interior in 1949. Its function is to administer the federal government's relationships with Indians, but as many Indians can attest, the B.I.A.'s services have been mediocre at best.

In 1923 and 1926, investigations of Indian reservations revealed that conditions in Indian country were deplorable. In 1928, another research team investigated reservations and produced its findings in the 872-page "Meriam Report, " which affirmed that Indians on reservations were poverty stricken, were receiving poor education and health care, and that the B.I.A. was ignoring these conditions. Because of the severe problems, in 1934 the Indian Reorganization Act (also known as the Wheeler-Howard Act) was passed. It ended allotment, established a school fund, re-established tribal governments and allowed Indians to adopt tribal constitutions drafted by the B.I.A. that permitted tribes to make some of their own decisions. The I.R.A. also attempted to bring Indians into the B.I.A. by allowing them to bypass civil service examinations. Money was alloted for Indians to begin agricultural and industrial projects, bilingual texts were printed, schools were established, and Indians were encouraged to preserve what was left of their traditions.

These relatively positive I.R.A. policies quickly came to an end. Because some Euro-Americans believed that Indians were given special treatment, and because tribal lands contained coal, timber, gas, and other mineral resources, non-Indians pressured Congress to open Indian lands for exploitation. In the 1950s, the Federal Government attempted to terminate the reservations, seeking to relieve itself of responsibility for Indians by casting them adrift. Though Congress passed Public Law 280, which allowed six states to extend their civil and criminal laws over reservations within their borders, many states were overburdened and could not or would not extend social services to Indians. Because federal funding was cut off, tribes such as

the Menominees in Wisconsin went from prosperity to near destitution. Many Indians across the country were forced to sell their lands in order to survive.

Relocation also was a part of the termination policy; it involved the forced emigration of over 35,000 Indians to urban areas, even though many were totally unprepared for city life. Hundreds of Indians did not know how to use the telephone, how to fill out job applications, or how to manage money. Needless to say, the policy of termination only served to aggravate Indians' problems.

Both political parties in the 1960 election were aware that the termination policies were not in the Indians' best interests. Kennedy assigned a commission to study the Indians' conditions and the result, published as *The Indian: America's Unfinished Business,* argued for a sound land base in order for Indians to have a prosperous future. Housing was somewhat upgraded on reservations, Indians were again able to borrow money from the government for investment purposes, and industries were established on some reservations. The policy of termination formally ceased in the late 1970s.

As stipulated by the 370 or more treaties between the United States and Indian tribes, the U.S. is obligated to provide social and health services to tribes in exchange for the Indians' lands. Yet because of the B.I.A.'s budget cuts and what many Indians regard as inefficiency, many reservation Indians continue to suffer from a variety of problems, such as poor housing, inadequate health care and education, unemployment, poverty, racism, prejudice, and stereotyping. The federal government has been slow to correct such problems.

American Indians suffer far more from diseases than do non-Indians, and they die earlier. Indians suffer in higher percentages from tuberculosis, alcoholism, diabetes, infant mortality, low birth weight, and gastrointestinal and cerebrovascular diseases than other citizens. In addition, homicide and suicide rates are almost double among Indians. Numerous Navajo children have tested positive for herpes viruses, and more than half of the Arizona Pimas suffer from diabetes.

To combat the numerous health problems, Congress created the Indian Health Service (IHS) in 1954. This sub-agency of the Department of Health and Human Services provides medical

services to those with one-quarter or more Indian blood. There are eleven regional IHS administrative units, with several hundred hospitals, outpatient clinics, and health stations. The numbers of health care facilities are deceiving, however, for many are poorly operated and lack qualified health care professionals. Some do not have facilities for surgery.

The unemployment rate for American Indians is lower than for the rest of America. In 1980, 12.4 percent of the United States population lived below the poverty level, compared to 28.2 percent of the Indian population. Many reservation Indians attempt to work in urban areas, but they usually receive little assistance in acquiring jobs. Many have no job skills, and some don't know how to drive a car, use a telephone, fill out applications, or understand the need to be at work on time. In addition, some have drug, family and self-esteem problems, lack consistent work histories, and feel the need to return to the reservation frequently for religious ceremonies.

Unemployment is rampant on reservations. There are almost no private sector jobs, and those on reservations must depend upon the B.I.A., the tribal government, or the health service for employment. Banks hesitate to invest in reservation enterprises because Indian land cannot be used as collateral, and tribes are not liable to lawsuits. Most tribes do not have any way of providing their own capital, and few members have business experience.

The number of Indian youths is increasing, yet they have the lowest rates of high school graduation. Many factors contribute to Indian students' difficulties in school, including lack of cultural understanding and language differences between teacher and pupil, lack of parental involvement, and the cultural conflict between what is taught in the public schools compared to what the child learns at home. Another factor is that children often have to travel significant distances to attend school.

These problems are quite similar to those faced in earlier times by children who were forced to attend federal boarding schools. These schools were established with the goal of converting Indian children into imitation Euro-Americans. In an attempt to make students lose interest in their tribal cultures, Euro-American teachers informed them that their cultures were inferior to "white culture," and forbade them to speak their native languages or

practice their religious ceremonies. Violators were subject to physical punishments. Needless to say, many children despaired.

Many federally-funded schools operated by the B.I.A. have inadequate textbooks, deteriorating dormitories, mismanaged funds, and underpaid and improperly certified teachers. In 1984, officials at the Phoenix Indian School (now closed) were found to use mace, straitjackets and shackles to discipline students. Between 1981 and 1987, at least 125 Indian pupils were molested by their teachers on the Navajo, Hopi and Havasupai reservations.

Given their current situation and historic abuses, why then would Indians celebrate the Fourth of July? After all, the Declaration of Independence refers to them as "merciless Indian savages." Many Indians ask why they should celebrate Columbus Day when, in their opinion, this country was settled by invaders at the expense of the peoples who already lived here? Indians have no problem with giving thanks for what they have, but why celebrate the American "Thanksgiving," when Pilgrims proceeded to massacre the Wampanoags who helped them survive after they arrived on the shore of Narragansett Bay?

Many Indians, including members of Vietnam veterans groups, do, however, celebrate Veterans' Day. Thousands of men and women have served this country in every war in which it has participated. The Navajo Code Talkers have only recently been honored in Washington D.C., despite the fact that they played a major role in helping the victorious Allies during World War II. Indian Code Talkers from other tribes are rarely mentioned, if at all.

History cannot be interpreted from one point of view. America needs to reconsider what it celebrates, and to recognize the fact that not all Americans celebrate the same timemarks and accomplishments.

Recommended Readings:

American Council on Education, "Minorities in Higher Education," *Tenth Annual Status Report, 1994,* 13th annual report (Publications,

Miner, Craig H. *The Corporation and the Indian: Tribal Sovereignty and Indian Civilization in Indian Territory,1867-1907* (Columbia: University of Missouri Press, 1989).

Neirhardt, John G. *Black Elk Speaks: Being the Life Story of a Holy Man of the Oglala Sioux as Told Through John G. Neihardt* (Lincoln:

Gallup Indian ceremonial c1940 by Beatien Yazz. The town is making money because of the Indian attractions, but ironically, the sign in the door reads, "No Indians allowed." (*Courtesy School of American Research, Santa Fe, New Mexico*)

Department M, One Dupont Circle, Washington, D.C., 20036)

Andist, Ralph. *The Long Death* (New York: Macmillan and Co., 1964).

Blumenthal, W. *American Indians Dispossessed: Fraud in Land Cessions Forced Upon the Tribes* (Philadelphia: G.S. Macmanus, 1955).

Bureau of Indian Affairs (B.I.A.), "Indian Services and Labor Force Estimates" (Washington, D.C.: U.S. Department of the Interior, January, 1989).

Burt, Larry. *Tribalism in Crisis: Federal Indian Policy, 1953-1961* (Albuquerque: University of New Mexico Press, 1982).

Debo, Angie. *And Still the Waters Run* (Norman: University of Oklahoma Press, 1989).

Deloria, Vine. *Custer Died for Your Sins: An Indian Manifesto* (New York: Avon Books, 1970).

Fixico, Donald L. *Termination and Relocation: Federal Indian Policy, 1945-1960* (Albuquerque: University of New Mexico Press, 1986).

Foreman, Grant. *Indian Removal: The Emigration of the Five Civi-lized Tribes of Indians* (Norman: University of Oklahoma Press, 1932).

Hagan, William T. *Indian Police and Judges: Experiments in Accultu-ration and Control* (New Haven: Yale University Press, 1986).

Hall, Gilbert L. *The Federal-Indian Trust Relationship: Duty of Protection* (Washington, D.C.: Institute for the Development of Indian Law, 1979).

Hauptman, Larry. *The Iroquois and the New Deal* (Syracuse: Syracuse University Press, 1982).

Horsman, Reginald. *Expansion and American Indian Policy, 1783-1812* (East Lansing: Michigan State University Press, 1967).

Indian Health Service (I.H.S.), *Regional Differences in Indian Health* (U.S. Department of Health and Human Services, 1989).

Idem. Trends in Indian Health, 1989 (U.S. Department of Human Services, 1989).

Jackson, Helen Hunt. *A Century of Dishonor* (New York: Harper and Brothers, 1881).

John Elizabeth A. H. *Storms Brewed in Other Men's Worlds: The Confrontation of the Indians, Spanish, and French in the Southwest, 1540-1795* (Lincoln: University of Nebraska Press, 1981).

Josephy, Alvin M. *The Nez Perce and the Opening of the Northwest* (New Haven: Yale University Press, 1965).

Idem. Now That the Buffalo's Gone: A Study of Today's American Indians (New York: Alfred A. Knopf, 1982; reprint, Norman: University of Oklahoma Press, 1984).

Kelly, Lawrence. *The Assault on Assimilation: John Collier and the Origins of Indian Policy Reform* (Albuquerque: University of New Mexico Press, 1983).

Lauber, Almon Wheler. *Indian Slavery in Colonial Times Within the Present Limits of the United States* (New York: Longmans, Green, and Co., 1913).

Miner, Craig H. *The Corporation and the Indian: Tribal Sovereignty and Indian Civilization in Indian Territory, 1867-1907* (Columbia: University of Missouri Press, 1989).

Neirhardt, John G. *Black Elk Speaks: Being the Life Story of a Holy Man of the Oglala Sioux as Told Through John G. Neihardt* (Lincoln: University of Nebraska Press, 1961. reprint).

Parman, Don. *Navajos and the New Deal* (New Haven: Yale University Press, 1976).

Peroff, Nicholas. *Menominee Drums: Tribal Termination and Restoration* (Norman: University of Oklahoma Press, 1982).

Philp, Kenneth R. *John Collier's Crusade for Indian Reform, 1920-1954* (Tucson: University of Arizona Press, 1977).

Prucha, Francis Paul. *The Great Father: The United States Government and the American Indians 2 vols.* (Lincoln: University of Nebraska Press, 1984).

Sheehan, Bernard W. *Seeds of Extinction: Jeffersonian Philanthropy and the American Indian* (Chapel Hill: University of North Carolina Press, 1973).

Spicer, Edward H. *Cycles of Conquest: The Impact of Spain, Mexico, and the United States on the Indians of the Southwest, 1533-1960* (Tucson: University of Arizona Press, 1962).

Stannard, David E. *American Holocaust* (New York: Oxford University Press, 1992)

Szasz, Maragret. *Indian Education in the American Colonies, 1607-1783* (Albuquerque: University of New Mexico Press, 1988)

Thompson, Gerald. *The Army and the Navajo: The Bosque Redondo Reservation Experience, 1863-1868* (Tucson: University of Arizona Press,1976).

Worcester, Donald, ed. *Forked Tongues and Broken Treaties* (Caldwell, Idaho: Caxton Printers, 1975).

Wrone, David R. and Russell S. Nelson, Jr. *Who's the Savage?: A Documentary History of the Mistreatment of the Native North Americans* (Greenwich: Fawcett Pubs., Inc., 1973).

STEREOTYPE
Indians get a free ride from the government

REALITY
The benefits Indians receive from the government derive from treaty agreements, which purport to compensate them for the surrender of some or all of their invaluable lands

Indians do not receive money from the federal government just because they are Indians. When I taught high school in New Mexico, many of my non-Indian students were convinced that the Indian students "had it made;" they believed that the latter received food, clothes, cars, eye glasses, an undetermined amount of cash, and no doubt an automatic university scholarship after graduation. Non-Indian students who did not have their facts straight were also angry when members of the cross country team—all but one runner was Indian—received several pairs of running shoes a year, even though the reality was that all athletes in all sports were supplied equipment, not just Indians.

So, do Indians really receive free goodies from the government? Do they drive Cadillacs and take groceries bought with food stamps back to sumptuously-furnished homes? These questions probably sound ridiculous to many Indians who live in terrifying poverty with no transportation, no running water, electricity, or telephones (though some people don't want these things), and who receive little, if any, assistance from the government.

Ironically, many non-Indian residents of border towns complain about how Indians "sponge" off the government, but these same towns enjoy a substantial week-end profit boom because of the numbers of Indians who spend their money at grocery stores, department stores (such as Wal Mart, K-Mart, and Target), restaurants, and car dealerships. Non-Indians hosting garage sales often report that Indians buy everything they have for sale. Interestingly, a car-dealership acquaintance of ours

commented that Indians are his favorite customers because, "They're too stupid to offer a bid lower than the sticker price."

Not all Indians, however, can afford to spend money. Church groups and other philanthrophists often help needy Indians by donating food, clothing and shelter. Northern Arizona University sends students to reservations to help renovate dilapidated houses and buildings courtesy of its' "Project Volunteer" program. About ten years ago, Texas Christian University raised enough money to buy land for the destitute Kickapoos who were living under a bridge in Eagle Pass, Texas.

Some Indians do receive various forms of aid from the U.S. government, but this aid is a result of treaty agreements in which the tribe in question ceded (often by force) most of its land in exchange for government protection of the remaining tribal land, and health and educational aid, among other things. Some Indians do receive checks from the government, but this money is *payment* owed them for their land that has been leased. Since the government holds the land in trust for Indians, it is the government that collects the lease money, which in turn distributes the money to tribes. Indians have the right to own, lease, and to sell property like anyone else.

Some reservation Indians depend upon the government for some services, such as health care, education, and housing, but Indians are not by any means totally dependent upon the government. Urban Indians are as self-sufficient as non-Indians. Many have high-paying jobs with all the benefits such as health and life insurance. Privately owned businesses operate on most reservations, and some tribes are developing tourism industries. It is often a challenge, however, for tribes to start businesses. Acquiring loans is difficult, for tribal land cannot be used as collateral, and many tribal members do not possess business skills.

All Indians pay federal income taxes, except for moneys earned on their allotments. But because of the tribes' quasi-sovereign status and primary relationship with the federal government, states cannot tax an Indian's income if earned on a reservation, nor can states tax reservation land or allotments. Indians who live on reservations pay no corporate taxes, nor are they required to buy state licenses for Indian-owned businesses on reservations. Indians working in urban areas, however, must pay state income and other taxes.

American Indians are U.S. citizens and those living in urban areas are subject to federal and state laws—just like everyone else. Indians living on reservations are subject to federal and tribal laws. Because of treaty stipulations (again, rights given to Indians in exchange for land cessions), Indians on some reservations may have certain rights that non-Indians do not have, such as being exempt from purchasing game licenses, yet they are required to uphold conservation laws.

Although tribes may possess certain powers, these powers are not unlimited, nor is the funding they receive. Many non-Indians are quite hostile to the rights Indians possess by law and continue to believe all Indians are lazy loafers waiting for their welfare checks. A few may be, but Indians are not the only ones in this country on welfare. Any needy, unemployed American, not just Indians, can apply for welfare and food stamps. In order to receive government aid from the Bureau of Indian Affairs, Indians must be recognized members of a tribe and be at least 1/4 or more Indian blood and must live on or near reservations. Obviously, some Indians do receive assistance from the government, but most do not.

It is an irony that Indians are stereotyped as dependent upon the government for everything, when in actuality they are engaged in an arduous struggle simply to retain their rights and indeed, maintain their very existence.

The United States government also does not bestow "special rights" upon tribes. By terms of the hundreds of treaties with Indian tribes, the United States is required to protect tribal lands and the tribes' existence.

STEREOTYPE
*Indians' affairs are managed for them
by the Bureau of Indian Affairs*

REALITY
**Each tribe has its own governmental structure
possessing a variety of self-governing powers**

Although many Indians believe that tribes should be completely sovereign, the U.S. federal government considers the tribes on the almost 300 reservations to be quasi-sovereign, domestic, dependent nations. The United States government, in what many believe to be an abuse of its role as the stronger sovereign, retains the questionable right to eradicate tribal authority, which presently includes the power to formulate and enforce their own laws, to structure their governments, and to decide their tribal membership.

Federal Indian agents do not live on reservations in order to tell tribes what to do. Each tribe has its own governmental organization, usually with a constitution and councils that oversee tribal businesses, finances, programs, and policies. Leaders are usually elected and are known either as "President," "Chief," "Governor," "Chairman," or "Chairwoman." About half of all tribes operate their governments based on Indian Reorganization Act guidelines. Some tribal governments are highly sophisticated, while others are still developing. The Navajos' original political system, for example, was loosely organized, with headmen taking charge in times of need. Today the official governing body of the Navajo Nation is the 88-member Navajo Tribal Council. An eighteen-member advisory committee collaborates with the President of the tribe in regard to overall tribal administration; the advisory committee is in turn assisted by thirteen committees, each specializing in a vital area such as health care or social services. In order to prevent abuses of power by the tribal leader, the Chairman's title has been changed to "President," to indicate adherence to a notion of separation of powers/checks and balances

similar to the federal system, and the power of the tribe's judicial branch of the new tripartite government was increased to ensure the division of authority among the three branches.

The federal government is responsible for protecting Indian lands and resources (including wildlife, water, minerals, and hunting and fishing rights), and for providing necessary social services (health care, education, housing, transportation development and food distribution).

Because the tribes are inherently sovereign, individual states may not exercise authority over them unless authorized by Congress. In Arizona, for example, the only state laws implemented on reservations pertain to air and water pollution. Tribes define memberships and have jurisdiction over marriage, divorce, child welfare and inheritance. They also regulate economic enterprises on their reservations, and may levy taxes on non-Indian businesses. They also have jurisdiction over land leasing and zoning, but they cannot conduct foreign relations or reallocate their lands.

Recommended Readings:

Cohen, Felix. *Handbook of Federal Indian Law* (Albuquerque: University of New Mexico Press, 1942).

Deloria, Vine and Clifford M. Lytle. *American Indians, American Justice* (Austin: University of Texas Press, 1983).

Deloria, Vine, ed. *American Indian Policy in the TwentiethCentury* (Norman: University of Oklahoma Press, 1985).

Hall, Gilbert L. *The Federal-Indian Trust Relationship: Duty of Protection* (Washington D.C.: Institute for the Development of Indian Law, 1979).

O'Brien, Sharon. *American Indian Tribal Governments* (Norman: University of Oklahoma Press, 1989).

Schusky, Ernest, ed. *Political Organization of Native North Americans* (Washington, D.C.: University Press of America, 1980).

Utter, Jack. *American Indians: Answers to Today's Questions* (Lake Ann, Michigan: National Woodlands Publishing Co., 1993.

Wardel, Morris. *A Political History of the Cherokee Nation, 1838-1907* (Norman: University of Oklahoma Press, 1938; reprint, 1977).

Wilkinson, Charles. *American Indians, Time, and the Law* (New Haven: Yale University Press, 1987).

STEREOTYPE
Indians are not capable of completing school

REALITY
**Hundreds of Indians graduate from universities
every year**

Recently, an Indian graduate student complained to me about a comment she had heard about herself. One professor had remarked to another that the only reason Indians were in graduate school was because the school needed to fill its minority quota. I could sympathize because I had heard the same thing about myself throughout graduate school. I was also told by a Euro-American professor the year I arrived as Assistant Professor that there was no need for Indian history on the graduate level because "Indians can't handle graduate work." Because some Indians have not been properly prepared for their university tenures, professors still believe most Indian students are mentally deficient and feel that they must "give them a passing grade" out of sympathy.

Minorities do enroll in universities, but they are just that — in the minority. Most of them must appear to loom ten feet tall and eight feet wide, for many non-Indian students and professors are convinced that their predominantly Euro-American campuses are being overrun by American Indians, African Americans, Mexican Americans, and Asian Americans. Many non-Indians also believe that Indian professors, administrators and staff are hired because of their race — not their qualifications. Occasionally this may prove to be true, but generally Indians are just as qualified as their non-Indian counterparts.

Indians have always been educated according to the ways of their particular culture. Male and female children of all tribes were taught to hunt, track, make weapons, cook, sew, tan hides, preserve foods, make shelter, etc., depending on the gender roles. One tribe, the Cherokee, had its own alphabet completed by Sequoyah (also known as George Guess) in 1821. It allowed even

staunchly conservative Cherokees who were not interested in "white education" to record their sacred songs and ceremonies for future generations.

Indians have been attending Euro-American schools and colleges ever since their initial contact with Europeans. In 1621, in the settlement of Jamestown, Virginia, Indian children were taught at the East Indian School, and a few attended Harvard and Dartmouth Colleges during the schools' early years. In the Southeast, missionaries established schools among tribes in the eighteenth century, and some mixed-blood, acculturated Indians, like members of the "Five Civilized Tribes" (Cherokees, Choctaws, Chickasaws, Creeks, and Seminoles — tribes deemed "civilized" by non-Indians because of their high rate of intermarriage with Euro-Americans and the adherance to Euro-American cultural values by many of their members) also established schools for their children. Cherokees and Choctaws enrolled in New England schools such as Cornwall Foreign Mission School in Connecticut.

Cherokees of Indian Territory established dozens of public schools and in 1851 opened two seminaries, or high schools, in order to allow young Cherokees to continue their education past the elementary grades. After graduating from the seminaries — the courses of study of both were patterned after Mount Holyoke Female Seminary in Massachusetts and Yale — several hundred Cherokee men and women attended colleges and universities across the country, and became physicians, lawyers, educators, real estate agents, bankers and social workers. Several men served as Principal Chief of the Cherokees. Some were inducted into the Oklahoma Memorial Hall of Fame.

Today over 400,000 Indian children between 5 and 18 years attend public, private, parochial and B.I.A. schools. Indians control twenty-four colleges that are attended by approximately 14,000 students. These colleges have created curriculums to serve the needs of Indian students who intend to serve their tribes after graduating. But the majority of Indian students in higher education attend mainstream colleges and universities across the country and in foreign countries, and most do not major in "Indian Studies." Despite racism, opposition to "political correctness" on campuses across the country, and exclusionary policies that disallow Indians with low grade point averages to

enroll in certain programs — even though many students with poor academic backgrounds have demonstrated that they can successfully graduate after being properly trained — many Indians do graduate and become successful physicans, lawyers, educators, counselors, mechanics, engineers, nurses, scientists, tribal leaders, law enforcement officers, politiciáns, social workers, artists, writers, musicians, architects and athletes.

In 1990, the American Indian and Alaskan Native Professors' Association was formed in an attempt to create a much-needed support network for American Indians with PhDs. Other organizations, such as the Native American Science and Engineering Society, American Indian Business Association, American Indian Council of Architects and Engineers, American Indian Law Students Association, Association of American Indian and Alaskan Native Social Workers, Association of American Indian Physicians, Society of Indian Psychologists, and National Indian Education Association also lend support to Indian students and professionals. While fully possessing the abilities to graduate from any institution, many Indians prefer not to, feeling either that the information taught in schools conflicts with their traditional beliefs, or that they do not need to earn a degree to find employment.

Recommended Reading:

The Carnegie Foundation for the Advancement of Teaching. *Tribal Colleges: Shaping the Future of Native America* (Princeton: Princeton University Press,1989.

Fuchs, Estelles, and Robert J. Havighurst. *To Live on This Earth: American Indian Education* (Garden City, New York: Doubleday, 1972).

Mihesuah, Devon A. *Cultivating the Rosebuds: The Education of Women at the Cherokee Female Seminary, 1851-1909* (Urbana: University of Illinois Press, 1993).

Szasz, Margaret. *Education and the American Indian: The Road to Self-Determination, 1928-1973* (Albuquerque: University of New Mexico Press, 1974).

Idem. Indian Education in the American Colonies: 1607-1783 (Albuquerque: University of New Mexico Press, 1988).

STEREOTYPE
Indians cannot vote or hold office

REALITY
**Indians represent a powerful voting bloc in elections
Numerous Indians hold tribal, state and
national offices**

All Indians over eighteen years of age have the right to vote in local, state and federal elections, but only those recognized as members of their particular tribes can vote in tribal elections. In 1924, the Indian Citizenship Act declared all Indians United States citizens, although almost 75% of American Indians were already citizens, courtesy of treaties, statutes, and naturalization proceedings. Citizenship was also given to Indians who were honorably discharged during World War I. Indians were supposed to be able to vote, but some states, like Arizona, Utah and New Mexico, found ways to keep them from doing so by implementing literacy requirements and by declaring Indians on reservations as non-state residents. These laws have been repealed. Indians did not give up their tribal membership in exchange for American citizenship.

Indians serve at all levels of federal, state and local governments, and have been doing so for most of this century. William Wirt Hastings (1866-1938), for example, was a Cherokee who graduated from the Cherokee Male Seminary and Vanderbilt University. He later served, among other things, as Cherokee Tribal Superintendent of Education, Attorney General of the Cherokee Nation, President of the First Bank of Tahlequah, and from 1915-21 and 1923-34, was elected to represent the Second Congressional District of Oklahoma in the U.S. Congress. His ideas were also incorporated into the Oklahoma State Constitution in 1907. He was defeated for the Congressional seat in 1934 by a Cherokee woman, Alice Robertson.

President Herbert Hoover's Vice-President was Charles Curtis, a Kaw/Osage; Charles D. Carter (Choctaw), Will Rogers,

Jr. (Cherokee), William G. Stigler (Choctaw), Benjamin Reifel (Sioux), and Clem Rogers McSpadden (Cherokee) have served in the U.S. House of Representatives. Ben Nighthorse Campbell, a Northern Cheyenne, was elected to the House in 1986 and is now in the U.S. Senate. Indians who have served in the U.S. Senate include Hiram R. Revels (Mississippi Lumbee), Matthew Stanley Quay (Abenaki or Delaware), and Robert L. Owen (Cherokee). Across the country, Indian men and women serve at all levels of their tribal governments and the federal government, and they hold positions on city councils, school boards, and state legislatures.

Recommended Readings:

Unrau, William E. *Mixed-Bloods and Tribal Dissolution: Charles Curtis and the Quest for Indian Identity* (Lawrence: University of Kansas Press, 1989).

William Wirt Hastings (1866-1938) was a highly educated Cherokee who served for eighteen years in the U.S. Senate *(Courtesy Oklahoma Historical Society).*

STEREOTYPE
Indians have a tendency towards alcoholism

REALITY
Indians are no more predisposed to alcholism than members of any other ethnic group

During Northern Arizona University's Indian Heritage Week two years ago, a student relayed a typical story about Indians as drunks. In his sociology course, his professor asked the class, "What group in our town drinks the most?" One student raised her hand and answered that it was "the Indians." Incensed, a young Indian man stood up and announced that she had her facts wrong; the fraternities and sororities were the main contributors to the liquor trade in town, and that alcoholics are of all ages and races, and of both sexes.

This discussion is not uncommon, except that in most conversations nobody refutes the notion that Indians will drink anything containing alcohol and will then proceed to wallow in the gutters. The drunken Indian has been portrayed innumerable times in movies and in literature. Indeed, there are Indians who drink, including some who are alcoholics. Many, however, do not drink at all and some drink only occasionally, just like non-Indians.

Why does anyone turn to alcohol? Escapism, mostly, but sometimes people drink to relax, to get that "buzz," or to release inhibitions. With a few exceptions, Indians did not drink spirits copiously until the Europeans brought liquor to them. It was found to be a profitable trade item soon after contact, so trappers, traders and merchants found ways to bring alcohol to Indians in large quantities. Some Indians found it exciting to be intoxicated and an easy way to release frustrations. It was not long, though, before liquor was used by many Indians as a way to escape the grief of losing one's family, friends, lands and culture, as well as to mitigate the social isolation and homesickness they felt. The problem was so great that in 1902

the government made it illegal to sell liquor to Indians, though this was repealed in 1953. Today, depending on tribal laws, liquor may not be sold on many reservations, though many Indians and non-Indians make substantial profits by secretly selling it.

The rates of poverty, unemployment, disease, depression, and school drop-outs are much higher among Indians than non-Indians. While drinking too much can indeed cause problems, the degree of suffering which Indians as a population endure often encourages recourse to alcohol. Of course, Indians are not the only ones to drink in this country, historically or today. Drunkenness among other groups is often less visible due to the extent their positive socio-economic situation distances them from the streets, while the circumstances of Indians often force them to frequent cheap bars, where they become easy targets for public criticism. Such is the situation in Gallup, New Mexico, for example, which has become known for this problem.

Recommended Readings:

Colorado, Pamela, "Native American Alcoholism: An Issue of Survival," Ph.D. dissertation, Brandeis University, 1986.

Mancall, Peter C. *Deadly Medicine: Indians and Alcohol in Early America.* Ithaca: Cornell University Press, 1996.

STEREOTYPE
"My grandmother was an Indian"

REALITY
**Thousands of Americans "wannabe" Indian,
but they are not**

As a university professor and researcher who lectures on Indian topics, I have heard literally dozens of students, colleagues, audience members, and other Americans claim to have an Indian grandmother (rarely a grandfather). These would-be descendants usually have several things in common: 1) they do not have any documentation to prove tribal membership; 2) they are not exactly sure to which tribe she belonged; 3) she's no longer living, so it is impossible to get more information from her and for some reason, family members know little about her; 4) there is no documentation because the ancestor was "ashamed" of her/his Indianness and "burned the documentation;" 5) documentation is not available because the ancestor was "out of town" during enrollment for allotment; 6) they know little, if anything, about tribal cultures; and 7) the grandmother was invariably a fullblood and you could tell because she had high cheekbones. While some claimants may indeed be part Indian but do not know much about that part of their family, others are what Kent Carter (Director of the National Archives, Fort Worth Branch, Texas), who has seen his share of them, calls "wannabes" and "outalucks."

Family legend is indeed a powerful force, and wannabes who are convinced that they had an "Indian Princess" for a grandma have even attempted to sue the Federal Archives because their ancestor is either nowhere to be found on tribal rolls or is on the "Rejected List." Another acquaintance of mine at the Federal Archives says that some Euro-American genealogists determined to find an Indian in the family woodpile have been disappointed to discover that their ancestors are indeed on tribal rolls — but as

"freedmen," i.e. African-Americans who were formerly held as slaves by some tribes in Indian Territory (now Oklahoma). Evidently, a black Indian ancestor is not good enough for some — it must be a red Indian. Even some prominent actors, writers, models and entertainers claim to be part Indian, such as Cher, Val Kilmer, Chuck Norris, Wayne Newton, and Lou Diamond Phillips (all supposedly Cherokees). There is no question that ethnicity is "in." Considering the numbers of Americans who desire to be part Indian (they rarely want to be a fullblood) but are not, this is undoubtedly related more to Indian stereotypes than to their realities, and as such is a psychological issue that I do not have the expertise to explain.

Many Americans wish to be Indians in order to qualify for benefits that they believe Indians receive. Although relatively few good Indian students receive free tuition or scholarships, many non-Indian students have discovered that they can choose to identify as Native American on university applications in an attempt to receive free tuition or solicit scholarly foundations for minority fellowships and grants. During the past few years, I have been saddened to discover that acquaintances of mine who did not use to be Indians are now in order to secure jobs. Fortunately, universities are beginning to screen potential students, faculty, staff and administrators for cases of "ethnic fraud."

Who is an Indian anyway? How is it that non-Indians get away with their claims of being one? Can all these people who claim to have an Indian grandmother really have one?

All Americans are given the choice of checking whatever box they want to on the census form, including Native American. This is called "self-identification," and many schools and employers often do not ask for proof of tribal membership. When the 1990 U.S. census permitted Americans to literally choose their ethnicity, there was a 37.9% increase in the count of Native Americans over 1980, to a total of 1,959,234 Indians, including 57,152 Inuits and 23,797 Aleuts. While liberalized tribal memberships and greater openness in expressing ethnic identity might account for some of the increase, many Indians believe that it is primarily due to the fraudulent claims -- for whatever reasons -- of non-Indians.

Tribal definitions, however, are different from self-identification. Each of the 511 federally recognized tribes determines

who are its members. Some tribes require members to be at least one-half blood on their mother's side, while others require that members be descendants of tribal members—sometimes down to the 400th degree. The key here is proof—you must prove that you had ancestors who were members of your tribe of choice, and that means that their names must be on tribal or government rolls. Tribal members usually receive a Certificate of Degree of Indian Blood (C.D.I.B.) and an enrollment card, but many non-Indians have obtained fake cards. The Bureau of Indian Affairs (B.I.A.) recognizes as Indians those people who are recognized by their tribe or who can prove descendancy from tribal or government rolls. In addition, one must be one-fourth or more Indian blood and live on or near federal reservations in order to receive B.I.A. services. The U.S. Department of Education defines an Indian as one who belongs to a state or federally recognized tribe. In some cases, a real Indian cannot find an ancestor on tribal or government rolls, but a letter of tribal recognition from tribal administrators or some other method will sometimes suffice as proof.

Despite these requirements set by tribes and government agencies, Euroamericans continue to claim to be Indian. This proves to be aggravating to real Indians, because scholarships go to frauds who have no intention of helping any Indian community after graduation, and jobs go to self-proclaimed Indians in the name of "affirmative action."

Non-Indians seek to capitalize on Indian ethnicity by other means as well. Non-Indians with self-given Indian names, dyed hair and turquiose jewelry portray themselves as medicine men and women, charging money for sweats and ceremonies. Other bogus Indians make jewelry, pots, blankets, rugs, and paintings to sell as "Indian art." Non-Indians dance and dress incorrectly at pow-wows and some imitate Indian dances for money. Unfortunately, many non-Indians cannot discern between real and fake Indians.

To verify your Indian ancestor(s), contact: Director, National Archives-Fort Worth Branch, P.O. Box 6216, Fort Worth, Texas 76115.

The addresses of tribal registrars are listed in Barry T. Klein, *Reference Encyclopedia of the American Indian* (West Nyack, NY: Todd Publications, 1990). At the very least, you will need to

supply the tribal registrar with your ancestor's full name, date and place of birth, possibly the same information regarding his or her parents and siblings, your birth certificate, and possibly your parents' birth certificates.

Recommended Readings:

Carter, Kent. "Deciding Who Can be Cherokee: Enrollment Records of the Dawes Commission." *Chronicles of Oklahoma* 59 (Summer 1991): 174-205.

Idem. "Wantabes and Outalucks: Searching for Indian Ancestors in Federal Records." *Chronicles of Oklahoma* 56 (Spring 1988): 94-104.

Hagan, William T. "Full Blood, Mixed Blood, Generic, and Ersatz: The Problem of Indian Identity." *Arizona and the West* 27 (Winter 1985): 309-326.

Porter III, Frank W. *Strategies for Survival: American Indians in the Eastern United States* (New York: Greenwood Press, 1986).

Chief Henry: Dressed in attire that is thoroughly un-Cherokee and standing in front of a tipi—a structure that Cherokees did not live in—wannabe Chief Henry plays at "Chiefin" in North Carolina. Henry is hailed as "the most photographed Indian in the world." *(Courtesy of Fern Mihesuah)*

STEREOTYPE
Indians are all full bloods

REALITY
The majority of Indians are of mixed heritage

Did Indians marry Indians of other tribes? Did Indians also intermarry with African-Americans, Mexican-Americans, and Asian-Americans? Yes, and they still do. Recently, one of my non-Indian graduate students began his review of John Walton Caughey's *McGillivray of the Creeks* by writing: "What is this? An Indian with a Scottish surname?" (Alexander McGillivray was a mixed-blood Creek, French and Scot who led the tribe in the late 1700s.) As the class discussion revealed, he was surprised that an Indian would have a "white name" and the student doubted that McGillivray could actually be Indian since he spoke English and went to Charleston to attend school. Many students also doubt the Indianness of the aforementioned Cherokees who attended the tribal seminaries since they had European features and were highly educated Christians. John Ross, the Cherokee chief from 1828 to 1866, was only one-eighth Cherokee blood and looked more like actor Hal Holbrook than any Indian.

Indians had intermarried with Indians outside of their tribes long before Europeans ever set foot on this continent. After Euro-Americans began to push many Indians off of their lands, tribes were forced to join with other tribes for protection. And since contact, many tribes also had members who intermarried with Euro-Americans, thus producing a population of mixed-bloods who either adhered to the value system of their Indian mothers or Euro-American fathers (more Indian women married Euro-American men than Indian men married Euro-American women). Some mixed-bloods knew the languages and customs of both parents' cultures and served as "cultural brokers" or "cultural mediators," while others floundered as outcasts in both worlds. The British were not tolerant of half-Indian persons who looked Indian despite their adherence to British culture, while

the French were more likely to embrace a mixed-blood as one of their own. In fact, French and Indian intermixing led to the emergence of a new ethnic group known as the Mètis who, in Canada in particular, regard themselves and are regarded as a separate ethnic group from either of their original ethnic components.

Tribes such as the Chickasaws, Choctaws and Cherokees of the Southeast began intermarrying with Europeans in the early eighteenth century. Many of the Cherokee mixed-blood off-spring, such as James Vann, became wealthy through inheriting their fathers' money. Some owned toll roads, inns, ferries, sawmills and extensive plantations, including the descendants of enslaved Africans to work their fields. Many of these mixed-bloods were highly educated and married Euro-American or other mixed-blood Cherokee women. Their children did the same, and because of this influx of "white blood" and values into the tribe, Cherokee culture changed dramatically. Many of the mixed-bloods had no interest in Cherokee traditions. They became Christians, earned degrees from universities (as early as the 1850s), and were proponents of acculturating their entire tribe to the ways of Euro-American society. Vann, Ross, Smith, Rogers, McNair and Adair are common Cherokee last names. Today there are Cherokees with only a 2,000th degree of Cherokee blood. But not all Cherokees were inclined to marry Euro-Americans, and there is a population of Cherokee fullbloods who are currently trying to keep their traditions alive.

Some tribes, such as those in the Iroquois Confederacy in the Northeast, the Apaches and Kiowas in the Southwest, and numerous others, adopted captive children from other tribes, as well as non-Indians (in the Southwest, many were Mexicans). Usually these people were meant to take the place of tribesmen and women who had died. "White captivity narratives" are quite popular among non-Indians, and one of the most famous of the captive Euro-American women was Cynthia Ann Parker, who was captured by the Comanches in Texas in 1836. She and her Comanche husband, Peta Nocona, had three children, one of whom became a leader of the tribe, Quanah Parker. After she was reunited with the Euro-Americans, Cynthia Ann pined away for her Comanche family and friends, and soon died. Her romantic story has resulted in the number of Euro-Americans

claiming to be descendants of Cynthia Ann to rival the number of folks claiming Cherokee descent, and in Texas—particularly around Parker County—numerous people claim to be members of both tribes. Interestingly, many of these people omit Peta Nocona as an ancestor, probably because military literature describes him as a "great greasy buck" and therefore unappealing as a great grandfather.

Many Indians today reap the benefits or suffer the consequences of the government's interference in determining the blood quantums of their ancestors. Some, in fact, have been made "more Indian" than they really are. Individuals of some tribes were given their blood quantum by federal agents based on appearance. For example, if one child looked phenotypically Indian, she was labeled a fullblood or close to it, while her brother with European features was given a lesser degree of Indian blood. Consequently, siblings from the same parents often ended up with different degrees of Indian blood. Members of some tribes which had their land allotted were recorded as fullblood regardless of their true degree of Indian blood. All those who were living with some tribes at a certain time were designated as fullbloods, even if they were Euro-American or Mexicans. A cluster of members of an Oklahoma tribe in Fort Worth, Texas, freely discuss their Mexican and Euro-American grandparents while boasting of a C.D.I.B. (Certificate of Degree of Indian Blood) card that reads four-fourths, which they are not.

Many Indians are quite defensive about their blood quantums. Some insist that the rolls are incorrect and they are more Indian than the documents reveal. Other would-be fullbloods won't admit that they are not truly 100% "pure" members of their particular tribe. For example, a graduate student I advised wanted to write her thesis on one of her prominent female ancestors—the wife of a well-known nineteenth-century tribal leader. To her dismay, the documents revealed that the ancestor was a Mexican captive, while family members that she needed to interview were adamant that the ancestor was not Mexican. Because this was a vital component of her study, the graduate student decided to abandon her topic in favor of something less controversial.

Some tribes in the Southeast kept enslaved Africans, and many mixed-blood children emerged from the amalgamation of African-American and Indian parents. In his study of the 1980

census, Jack Forbes estimated in 1988 that 30% to 70% of African-Americans have some Indian ancestry.

Recommended Readings:

Forbes, Jack. *Black Africans and Native Americans: Color, Race, and Caste in the Evolution of Red-Black Peoples* (Oxford: Basil Blackwell, 1988).

Griffith, Benjamin W., Jr. *McIntosh and Weatherford, Creek Indian Leaders* (University of Alabama Press, 1988).

Hagan, William T. *Quanah Parker: Comanche Chief* (Norman: University of Oklahoma Press, 1993).

Moulton, Gary E. *John Ross: Cherokee Chief* (Athens: University of Georgia Press, 1978).

Parins, James W. *John Rollin Ridge: His LIfe and Works* (Lincoln: University of Nebraska Press, 1992).

Wilson, Terry. "Blood Quantum: Native American Mixed Bloods," in Maria P.P. Root. *Racially Mixed People in America* (Newbury Park, CA: SAGE Publications, 1992), pp. 108-126.

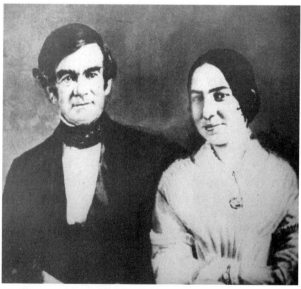

John Ross: Mixed-blood Cherokee John Ross and his second wife, Mary Stapler. Ross served as Principal Chief of his tribe from 1828 until his death in 1866. *(Courtesy Western History Collections, University of Oklahoma Library, Norman, Oklahoma.)*

STEREOTYPE
All Indians have an "Indian name"

REALITY
Most Indians have only a Euro-American name
A minority of Indians also have "Indian names"

Traditionally, most Indian infants and children received a special name that was in addition to the child's common name and was not often used. Sometimes today, in addition to their "American name" and nickname, Indian children are given a second "Indian name" in a naming ceremony. Because Euro-American society attempted to eradicate Indian names along with tribal culture, or because of many generations of intermarriage with Euro-Americans, many Indians have only an "American name."

Even fullbloods who have kept close to traditions almost always have an Anglicized name along with their Indian name. At boarding schools and when dealing with govenment agents, Indians were given names that were easy to pronounce by educators, Bureau of Indian Affairs officials, and missionaries. Some of the one or two syllable names were "American," like John, Charles, and Laura; sometimes the Indians' lengthy names were shortened. Obviously, names such as Sitting Bull, Red Eagle and White Bird are English translations of the individuals' Indian names.

Many Indians, especially in the 18th century, had European fathers and therefore Irish, English, French or German last names. A look at the Dawes Rolls of the Five Civilized Tribes of Indian Territory/Oklahoma reveals that many if not most individuals of some tribes have Euro-Americanized last names, much to the disappointment of geneaologists. Many Indians, however, have kept their traditional family names in their tribal language.

STEREOTYPE
Most Indians know the histories, languages and cultural aspects of their own tribe and of other tribes

REALITY
Few Indians know all cultural aspects of their own tribe, much less those of other tribes

This belief is not as uncommon as one might think. After all, many people believe that Indians are born with the ability to track and possess the visual acuity of eagles. When non-Indians discover that I am Choctaw, albeit mixed with French blood, they assume that I was born with not only the knowledge of my tribe's entire history, but also of the histories and cultures of every other tribe that has ever existed. I certainly do not know all these things, and it is doubtful that any Indian knows much more than his or her tribal aspects. Because many Indians may not have been raised within their tribe, or maybe because they are not interested, they often know nothing about any tribe's culture, not even their own.

Considering that many people believe all Indians are alike, why shouldn't we know everything about each other? American Indian professors of different tribes are often asked to sit together on "minority committees" under the administration's assumption that they all know each other's needs and wants. While minorities on campuses and within communities may indeed have needs and wants in common, they cannot speak for one other.

Children of all races are usually taught their particular culture's mores and to speak its language; these lessons continue throughout one's life. But it simply isn't feasible for Indians to know all about other Indians. To expect a person to understand the cultural aspects, languages and religious beliefs of 500 or so other groups is not only impractical, it is impossible. Why does one need to understand the language of a tribe that lives 2,000 miles away if one never plans to visit it? While practicing phrases

of greeting may be in order and assures that one does not commit a social *faux pas*, a thorough knowledge of another culture has no purpose unless you do business with the tribe on a regular basis, are intensely curious, highly intrusive, or actually live with it.

Some tribes, such as Navajos and Apaches, can understand each other because of language similarities — providing they can speak their own languages, which many cannot. This is not the same thing as possessing a comprehensive knowledge of another culture. Language, culture and social mores help shape a person's world view, and a true understanding of an Indian's world view cannot obtained by a few visits to a reservation, by watching a movie about Indians, or by reading about them.

STEREOTYPE
Indians are stoic and have no sense of humor

REALITY
Indians are as endowed with as rich a sense of humor as anyone else

Like the warlike Indian, the humorless, silent, wooden Indian is a popular image. Historic Indians are not painted or photographed smiling, and with good reason: often photographs were taken or portraits were drawn during a treaty-signing or after they had been captured.

Around non-Indians and people they do not know, many Indians do tend to be quiet and reserved, perhaps out of respect, suspicion, dislike or shyness—just like anyone else. Children of many Indian cultures are taught not to make eye-contact out of respect for another's privacy, and often they will not extend a robust handshake. Among non-Indians, a bone-crunching handshake may signify aggressiveness and self-assuredness, but among Indians that same firm handshake may be interpreted as domineering and rude. Many prefer a light touch that does not serve as a barometer of one's self-confidence.

Many a non-Indian teacher has been frustrated at the lack of class participation by their Indian students. In reality, those "withdrawn" students may be intensely emotional, highly intelligent and extremely inquisitive. Students may have been taught not to say that a teacher, another authority figure, or an elder is incorrect about something, or even to question them. Many Indian children are also taught not to put their heads above the others, that is, not to surpass their peers. Many teachers become aggravated with their Indian pupils because applications require prospective scholars to list their accomplishments, and some students are loathe to list them.

Coming from an oral tradition, some Indians can talk for hours and never repeat themselves. Amongst themselves, Indians are talkative and jovial; they tease each other and tell jokes that

would put *Evening at the Improv* guests to shame. Unless Indians feel comfortable around non-Indians or members of an alien tribe, the latter may never see their true personalities.

Recommended Readings:

Journal of American Indian Education, published by the Center for Indian Education, Arizona State University, Tempe, Arizona, 85287-1311.
Lincoln, Kenneth. *Ind'in Humor* (Oxford University Press, 1993).

An extra large Indian statue standing outside of Tucson, Arizona, either asking "how?" or demanding that tourists stop (Photo by Joshua Mihesuah)

STEREOTYPE
Indians like having their pictures taken

REALITY
Indians find photographers intrusive

Many photographers view Indians as curiosities, or as facets of nature much like scenery and wildlife, and see nothing wrong with invading an Indian's privacy in order to have a photo to frame or blow-up to poster size. Worse, some photographers take pictures of Indians without their permission for the purpose of publishing a coffee-table book that would bring revenue to the photographer—not to the subjects of the publication. Even when tribes make it prefectly clear that no cameras or tape-recorders are allowed onto the site of a sacred ceremony, such as a Sun Dance, it invariably happens that tourists manage to snap a few photographs anyway. Take a look in your local bookstore. There are probably dozens of expensive photographic publications on Indians, most likely on tribes of the Southwest. How many of these photos were taken by Indians? These books were not published for Indians. They already know what they look like.

The exceptions are those individuals who make a living at taking advantage of naive tourists. On the Cherokee reservation in North Carolina that is visited by thousands of tourists each year, tribespeople work at "Chiefin'," that is, dressing up in attire that is thoroughly untraditional to their tribe so that tourists can have their pictures taken with a real live "Indian Chief." Indians in other tourist hot-spot areas, such as the Black Hills, do the same thing. It appears that most tourists never consider that a real tribal leader would have better things to do than stand on a street corner in full regalia.

Indians in pow-wows or at tribal "homecomings" sometimes do not mind being photographed, but taking a person's photograph without permission should always be considered a transgression.

AFTERWORD
THE EFFECTS OF STEREOTYPING

Stereotyping American Indians is a form of racism that causes numerous problems, not only for those who are stigmatized, but also for those who perpetuate the myths. For the victims, false imagery most notably causes emotional distress: anger, frustration, insecurity, and feelings of helplessness. Those who stereotype suffer more subtly. Without attempting to learn about the people they misunderstand, they cheat themselves as well. They speak from ignorance and do not possess a well-rounded version of American history. They cannot appreciate what Indians have to offer because they refuse to believe that real Indians may be different from their images. Most of these people learn about Indians through hearsay and imagery, not from real Indians who could properly educate them.

Children are influenced at an early age by their peers, their parents, movies, and television. If Indian children see and hear Indians portrayed as savage, inferior and ignorant, they are likely to believe the same about themselves and to develop low self esteem. If Indians are exposed to widespread derogatory beliefs about Indians, many may feel that they can never accomplish anything because their *images* cannot. Some may believe their tribal cultures to be worthless and may hesitate to learn tribal traditions and to express their Indianness.

Racial intolerance often prevents Indians from enjoying the same socio-economic opportunities as other peoples do, making it difficult for them to integrate into mainstream society. Negative stereotypes of Indians encourage discrimination at work, in the marketplace, and in social settings. The stereotypes that Indians are perpetually dependent upon the government and that only a few "smart ones" are professionals, also leads to frustration for many Indians wanting to secure jobs or to purchase homes. For example, believing Indians to be economically unstable and unlikely to continue making their current salary, some real estate agents often ask their Indian clients to prequalify in order to avoid "wasting their time" in showing them property.

Grocery store checkers ask Indian customers for identification before accepting checks, yet they often do not ask the same of non-Indian customers. My husband and I have witnessed waitresses asking Indians to pay their bill upon serving their meal, presumably because they expect the diners to leave without paying.

In the academic workplace, university colleagues question the qualifications of minority faculty, insinuating that we are hired only because of our race and/or gender. Despite the number of qualified, award-winning American Indian scholars in the country, one California State University at Chico professor wrote to his city newspaper that, "Qualified faculty of Indian extraction do not exist." He proclaimed that minority faculty are "incompetent," and that "little more is required of Affirmative Action faculty than to show evidence of the vital life signs."[1] Attempts to prove ourselves the equals of our colleagues (even when we may be their academic superiors) results in extreme stress, early burn out, and cynicism concerning academia.

Indians also lose their authoritative voice in the world of academia. Most books on Indians are written by non-Indians who do not attempt to find Indians' interpretations of historical events and therefore write from a Euro-American perspective, evaluating tribes' cultures and histories by non-Indian standards. These individuals are situated in positions of power, determining what will (and will not) be published, which books merit awards, and which scholars will be presented with grants and fellowships. Year after year, the National Endowment for the Humanities, the Guggenheim Foundation, and the MacArthur Foundation award prestigious fellowships to scholars who write about Indians, many of whom are primarily skilled at writing grant applications and often never finish their projects or produce manuscripts devoid of Indian voice, thereby rendering the works incomplete. Despite applying to these and other foundations, few if any Indians, unless they are exceptional scholars, receive these major awards.[2]

Non-Indians do indeed take away from the authoritative voice of those who truly are knowledgeable. Many Americans believe that because they are university educated they "know it all," and they discount as incorrect what real Indians say about themselves, their histories, and cultures. Other non-Indians,

especially those claiming to be Indian spiritual leaders, make substantial profit from espousing New Age ramblings that have nothing to do with real tribal religions or cultures. Their followers dismiss the protests of real Indians as either jealousy or ignorance.[3]

Benefits of stereotyping

Stereotyping offers numerous benefits for those who perpetuate a distorted reality of Indians. In the entertainment field, producers make enormous profit from portraying Indians in the way the public *wants* to see them. *Dances With Wolves* (1990) is the epitome of romantic imagery of Indians and remains enormously popular. On the other hand, *Black Robe* (1991), a stark, realistic view of Hurons and missionaries in the 17th century, was not successful because the less attractive actors, violence, and unpleasant story line (the tribes were decimated by disease) did not adhere to audiences' fantasies of Indians.

Many other non-Indians make profit from Indian images by outright exploitation. Indian images serve as decoration for tee-shirts, posters, jewelry, clothing, industrial products, dolls, and sports teams paraphernalia.

Stereotyping also allows those who do it to feel superior to the group being stereotyped. Portraying Indians as something they are not has occurred since contact 500 years ago. Europeans labeled Indians "warlike heathens" in order to enhance their appeance of superiority as conquerors, and to justify tribes' extermina-tion, removal, or subjugation. More recently, Indians are portrayed as "stupid" and "lazy" by many Americans in order to justify their positions of poverty. Indians are also stereotyped negatively as savage antagonists in order to assuage the guilt Americans feel about the atrocities their ancestors committed against Indians in the past.

Some university professors believe Indians possess inferior educational backgrounds and different worldviews than non-Indians and therefore do not expect Indian pupils to complete the same amount of work as non-Indians. Sadly, many Indians complete their course of study without undergoing any rigor and are thus unprepared for an uncompromising world. A colleague once admitted to me that despite proof that one of her Indian graduate students plagiarized a paper, she does not "want to be

known as the professor who flunks Indians." Some professors simply want to boast that they "mentor" Indian students.

"Political Correctness"

Many Americans fear that minorities want a complete overhaul of academia, which means dispensing with the works of important "white guys" and replacing them with courses on minority histories and culture.

Indians do not argue for the elimination of Euro-American history and culture from school curriculums, nor do they call for the eradication of holidays that celebrate same. Instead, they desire more thorough curriculums that include Indians' contributions to American development, history, and culture, in addition to courses that focus on tribal life. While literature classes devoid of Shakespeare and Whitman, and art appreciation courses without Van Gogh and Monet are unthinkable, so should curriculums omitting the works of prominent minority writers and artists be considered incomplete. Educators and scholars should strive for objective truth, that is, a real version of United States history without side-stepping the ugly events in our nation's past such as slavery, massacres of Indians, religious intolerance, segregation, sweat shop labor, and stereotyping.

Many Americans claim they are "color blind" because they view everyone as equal. While the thought appears admirable, claiming "color blindness" shows a lack of appreciation of the distinct differences between peoples and cultures. The "melting pot" idea — that Americans, regardless of their history and ethnicity can someday intermingle to form one identity — is not reality, nor is it likely to be. In actuality, America is more of a "salad bowl," a country composed of peoples of different ethnicities that can often mix together like the ingredients of a salad but still retain their uniqueness. Americans need to be taught to recognize, respect, and understand these differences, not to ignore or depreciate them.

What Can Be Done?

There are numerous ways to combat stereotypes, and the home is a good place to begin. Parents should educate themselves about Indians so they can effectively monitor what their children watch on television and learn in school.

In the entertainment industry, Indians should be given the opportunity to write, produce, and direct movies and television shows. In academia, potential teachers need to become more educated about Indians, but this requires a change in the country's university system. Unless teachers are required to enroll in courses that focus upon minorities, they will continue to learn about Indians the same way almost everyone else does: through faulty images projected in movies and literature.

Publishing houses should print books about modern-day Indians, not just about those who lived in the past. Many Americans associate "Indianness" with what Indians used to be like, not with who Indians are today. Publishers also should hire American Indian readers and editors to assess potential manuscripts. A case in point is Ramon Gutierrez's *When Jesus Came the Corn Mothers Went Away: Marriage, Sex, and Power in New Mexico, 1500-1846* (Stanford University Press, 1991), a book that has won numerous academic honors. It has been hailed as a scholarly masterpiece by non-Indian academics, but Indians, most notably Pueblos, have severely criticized the author's methodology, interpretations, and historical "facts."[4] Gutierrez did not consult Indian informants for advice nor did the publishing house recruit Indians to read the book before it was disseminated to the public.

The public should question demeaning images of Indians that appear in newspapers and on local television stations by publicly voicing their concerns in letters to editors. Parents should take the time to serve on curriculum and textbook adoption committees, and teachers who desire to earn professional development credit should enroll in courses that focus on minority peoples.

There is much that can be done to eradicate demeaning stereotypes. With effort from parents, teachers, the media, and the entertainment industry, American Indians and their images may finally be treated fairly, truthfully, and with respect.

Notes:

[1]Joseph R. Conlin to Editor, February 28, 1993, *Chico Enterprise Record* and Commentary in *The Orion*, December 1, 1993.

[2]Vine Deloria, Jr. "Commentary: Research, Redskins, Reality," *American*

Indian Quarterly 15 (Fall 1991): 457-468.

[3]In her essay, "The Great Pretenders: Further Reflections on White Shamanisn," Hopi anthropologist Wendy Rose reflects on how the "Indian biz" has proved to be lucrative for non-Indians and how the non-Indian voice overshadows that of the Indians. In M. Annette Jaimes, ed. *The State of Native America: Genocide, Colonization, and Resistance* (Boston: South End Press, 1992), pp. 403-422.

[4.] See the evaluation of Gutierrez's book from a variety of Pueblo voices in "Commentaries," *American Indian Culture and Research Journal* 17:3 (1993): 141-178.

APPENDIX A
DO'S AND DON'TS
FOR TEACHERS AND PARENTS

1. *Avoid inappropriate terminology.*

Do not use "uncivilized" when comparing Indian cultures to Euro-American cultures. Use "different." The tribal and Euro-American cultures were different from one another, no one being inferior or superior.

Do not use "myth" to describe tribal creation stories and folklore; "myth" implies a made-up story. Use "account" instead.

Do not use "heathen" to describe those Indians who were and are not Christians. That implies that they had and have no religions. Use "Indians are religious" instead. Impress upon students that they do not have to believe what others believe, but they do need to respect others' right to believe as they wish.

Do not use the term "prehistory;" use "precontact" instead. "Prehistory" implies that Indians had no history worthy of recording until contact with Europeans. It is ironic indeed that Indians were here for thousands of years prior to the arrival of the Europeans, yet United States history texts usually only discuss the last 500 years.

Do not use the terms "brave," "buck," "squaw," or "papoose," when referring to Indian men, women and children. Men, women and children are apporpriate terms.

Do not call Indians "red skins." No Indian had or has red skin.

Do not use the singular when referring to a group of people. For example, using the singular "Cherokee" when referring to more than one member of that tribe is incorrect. It begs the question, "Which one?" The singular is how we refer to animals (the horse, the mule, etc.) and is demeaning to humans.

Do not say "Lakota Indians" or "Choctaw Indians." This is redundant.

Do not allow students and children to imitate Indians by saying "how" or "ugh." "How" is a Sioux word for hello. But did all Indians really hold up their hand and ask "How?" How what? Is not "how" also an English word? Asking "how?" or grunting "ugh" are insulting, nonsensical, verbal sysmbols of Indianness. So is yelling "Geronimo" when jumping off a diving board.

Do not tell students and children to stop acting like "wild Indians." Indians were and are no more "wild" than Europeans, Africans, Asians, Hispanics, or any other ethnic group.

2. Instill a sense of diversity.

Students should understand that American Indians are not all alike. Give pupils examples of tribes that lived on the coast, in the deserts, the forests, the Arctic. All had different languages, religions, clothes, housing, foods, etc. Indians are multifaceted peoples who should not be generalized. Each tribe has its own complex history, culture and name for itself. It is a mistake to generalize Indians, just as it is incorrect to generalize Europeans, Africans, Hispanics or Asians.

3. Tell students about Indians today.

Because of movies that romanticize the horse-riding, bison-hunting Plains tribes (i.e. *Dances With Wolves*), many Americans have the impression that not only are all Indians alike, but they also exist only in the past. Students must learn that Indians are alive in the present and are working in every segment of society (see Chapter 7).

Also, they do not all look alike. Many of the men do not have long hair and many Indians are mixed-bloods with lighter coloring. (see Chapter 19) Most Indians do not live on reservations and those that do, do not have to stay there (see Chapter 12).

4. Do not have students dress as Pilgrims and Indians for Thanksgiving.

This is as dishonest as playing "happy mammy and plantation owner's wife." After all, Pilgrims, Puritans and other colonists thought that Indians were heathens and savages, and according to some, the Devil's disciples. Within 50 years of the "Thanksgiving Feast," thousands of Indians were dead at the hands of colonists and disease. Thanksgiving indeed. In fact, many Indians recognize Thanksgiving as a "Day of Mourning."

Do not have students make headdresses to wear. The style, materials and significance of headdresses varied from tribe to tribe and not every tribal member wore one. Indian men certainly did not wear headdresses to play in, nor should non-Indians.

Do not have students dance like Indians, nor should they beat a drum. Social and religious dances have deep meaning for tribes and any attempt at imitation is ridicule. Drums are played by men and each song is significant (see Chapter 10).

5. *Use caution when expounding on America's "heroes" and use sensitivity when celebrating American holidays.*

Do not teach students that Columbus was a hero without examining his relations with Indians. The same can be said about George Armstrong Custer, Andrew Jackson, George Washington, William Henry Harrison, Teddy Roosevelt, and others who believed Indians to be inferior to Europeans (see Chapter 13).

The Declaration of Independence refers to Indians as "merciless savages." George Washington bought and sold Indian lands without tribes' permission, fought and killed Indians without mercy, and owned almost 500 African American slaves. In his book, *The Winning of the West*, Theodore Roosevelt wrote that Indians are "filthy," "leacherous" and "faithless, " in addition to living lives that "were but a few degrees less meaningless, squalid and ferocious than that of the wild beasts with whom they held joint ownership."

6. *Teach students the contributions of Indians to the growth and development of the United States.*

These range from new foods and medicines to ideas of democracy. Thousands of Indians have fought for America since the colonial period. Indians contribute to the arts and sciences yet their images are the focus of entertainment and revenue for non-Indians (see Chapter 7).

7. *Teachers should fight for more well-rounded curriculums that include minority peoples.*

This includes critically reviewing textbooks that claim to but do not include a complete history of this country. They also should push for multi-cultural curriculums. It is important for

all of us to attempt to correct false history, for today there are at least 2 million American Indians in this country and millions more in Central and South America. Their histories and cultures deserve to be portrayed as accurately as those of any other race or culture.

8. *Use caution when utilizing Indian "artifacts" for instruction and screen students' show and tell items.*

Certain items should not be used for educational purposes and many should not even be in the possession of non-tribal members. For example, many tourists collect pottery shards from Indian ruins, but these items *are part of the ruins.* So many tourists have walked off with these souvenirs that forest service officials are considering closing selected sites.

Skeletal remains should never be exhibited. Indian remains have been unearthed on private properties, but in many states, laws have been passed declaring it illegal for landowners to excavate on their own property. Many Americans, however, have Indian skulls displayed on their coffee tables.

Other items such as medicine bundles, pipes and pipe bags are sacred items and non-Indians should not possess them. Often, drums, jewelry, kachina dolls and clothing were obtained from burials and teachers sould ascertain the origin of these items.

Obviously, teachers and students should not possess sacred tribal items that were acquired illegally, but often the buyer is unaware of exactly what they are purchasing, or where it came from.

APPENDIX B
SUGGESTED GUIDELINES
FOR INSTITUTIONS WITH RESEARCHERS
WHO CONDUCT RESEARCH ON
AMERICAN INDIANS*

Since contact, non-Indians have been fascinated with American Indians and they continue to explore almost every aspect of Indians' cultures and physiologies. Library shelves contain vast collections of books with American Indian themes. The majority of books and articles, in addition to movies, television shows, and documentaries, have been written and produced by non-Indians (some of whom attempt to pass themselves off as Indians), who have in turn been educated and trained to conduct research by other non-Indians. Although most non-Indian and Indian scholars respect the peoples and cultures they study, many do not. Intrusive research of American Indians and publication of information that tribes do not wish disseminated to the general public constitute a major source of inter-racial conflict. Dissention between those who desire to keep their cultures sheltered from curious interlopers, and those who cry academic freedom undermine the credibility of all scholarly studies.

The university tenure and promotion processes exacerbate the problem. Most university faculty members are encouraged to pursue a wide range of research and scholarly creative interests. Many of these projects focus on American Indian topics. Many researchers are intrusive in their quest for information, others are not. Some writers are genuinely concerned about their subjects' well-being and they research for the Indians' welfare. Indeed, many Indians are grateful that scholars have documented certain aspects of their culture and some tribes hire outsiders to conduct research for them. Most researchers, however, use the information for their own gain; that is, for tenure, promotion, grants, marketability, and prestige. Others operate under the assumption that they are the caretakers of tribal histories and cultural knowledge. These paternalistic encroachers claim that Indians are too witless to chronicle their own histories or to manage their own affairs, and they assume that it is in the Indians' best interest to publish sensitive details of tribal life. This posturing appalls tribal historians and religious leaders who maintain that certain aspects of tribal

* Reprinted with permission from the *American Indian Culture and Research Journal*, 17-3 (1993) 131-139.

information should not be shared with outsiders. The problem is that some people believe they should be exempt from any restrictions.

Two instances exemplify these boorish attitudes. First, a few years ago a professor at an Arizona university attempted to publish religious information about a tribe that is known to be extremely protective of its religion. (Many tribe members believe that the information was gathered from informants who were unaware that the information would be published.) Distraught, the tribal leaders hired a team of lawyers in an attempt to block publication of the book. To date, the manuscript has not been published, but despite the tribe's objections, the author continues to seek a publishing house that will accept it. Second, just last year, a full professor of my acquaintance, upon hearing that he may be subject to research restrictions, proclaimed that he could "study anyone and anything I damn well please." In the eyes of many American Indians and scholars, these imperial perspectives not only compromise the integrity of academic research, they also serve to alienate tribal communities from researchers who study Indians.

Until the time comes when Indians collect data about their own tribes and dictate what information will be disseminated to the public, researchers from outside the tribe of study should at least adhere to the general research guidelines of their particular academic and professional affiliations, Institutional Review Board Guidelines (I.R.B.s), and guidelines set forth by federal, state, and local governments. Investigators also should strictly adhere to the guidelines established by tribes and to the regulations of their funding agencies. Unfortunately, these guidelines are not always sufficient to protect American Indians from overzealous investigators.

In April 1991, Northern Arizona University President Eugene Hughes, upon recognizing the need for guidelines directed towards administrators, staff, faculty, and students who conduct research on American Indians, formed a five-member committee comprised of representatives from history, anthropology, modern language, and religious studies. Our group was thus named the Native American Research Guidelines Advisory Committee (N.A.R.G.A.C.).[1] The guidelines we established are intended to supplement the university's guidelines (such as the I.R.B. guidelines) by addressing religious, social, political, and other cultural aspects. However, they have not been formally approved and they may never be.

Some of the ideas I mention here may infuriate those researchers who are ardent subscribers to the imperialistic tenets of academic freedom. But considering the long history of exploitation of Indians at the hands of some non-Indians, it is only appropriate that the research of American Indians be monitored by universities and by tribes. What follows are a combination of NAU's guidelines and my additional suggestions for establishing a research guide.[2]

1. *Only the tribes' elected political and religious leadership should review and approve the research proposal.* It is not uncommmon for a researcher to obtain permission to study a tribe from one or two individuals, or from one tribal faction, and then claim that he or she has "tribal consent".The problem with this strategy (besides being unethical) is that the tribe may be divided along political, social, religious, geographic, or class lines. Progressive and traditional elements exist in almost every tribe. Not all members of the same tribe subscribe to the same values, support the same tribal politicians, or live in the same area. Many Indians know nothing about their cultures.

Because of the socio-economic differences between members of the same tribe, a variety of situations may arise to complicate the researcher's study. For example, some tribal members may not be initiated into certain religious societies and do not know enough to tell researchers factual information. On the other hand, maverick tribal members may be inclined to reveal secret tribal religious knowledge for monetary gain, and some individuals may reveal private information under the assumption that the researcher will not make public the information. It is important that researchers deal with the tribes' leadership and not take advantage of intra-tribal differences.

2. *Researchers should remain sensitive to the economic, social, physical, psychological, religious, and general welfare of the individuals and cultures being studied.* When individuals of different cultures interact, misunderstandings often result. What may be "ethical" and "respectful" to one group may be seen as "unethical" and "disrepectful" by another. Behaviors can be interpreted differently. The well-published, grant-winning, aggressive researcher seeking knowledge may be admired among academics, but among other peoples he or she may appear to be nosey, pushy, and therefore offensive. The researcher may not understand the tribes' cultural mores, and indeed, he or she may believe that the Indians' cultures are inferior to his or her own (conversely, potential subjects may feel the same way about the researcher and his or her culture), but that should not deter the investigator from acting with the greatest sensitivity.

Peoples of non-Euro-American traditions may not share prevailing academic views on the gathering, distribution, and or publication of cultural information. They may not understand the need a person from one culture has to collect data from a person of another culture for curiosity's sake. For example, many non-Indians are fixated on Indian religions and they intrude on ceremonies and dances with tape recorder and camera in hand with the belief that Indians' religions are open to scrutiny by anyone. Some intruders want to participate in ceremonies and many imitate them. Witness the number of bogus medicine men and women in our country today. Many are frauds who conduct seminars with the intention of duping the ignorant public. Numerous

books on Indian religions have been criticized by tribes because of the unscrupulous ways information was obtained.

It also must be kept in mind that many tribes will not object too strenuously to a topic because it might reveal facts. A potential publisher of the aforementioned religious book was confused when tribal members argued that many parts of the book were inaccurate, but would not tell editors why because religious leaders did not want the correct information revealed.

3. If you are preparing a grant application that deals with Indians, give yourself months, if not a year, to allow the subjects to thoroughly understand every aspect of what you will be doing. The Hopis, for example, take at least a year to approve research projects, and there is a good chance that they may dissapprove of your study. It is not wise to write a grant application under the assumption that the tribe will cooperate.

4. Use caution when using cameras and tape-recorders. Make certain that informants understand what you will do with the pictures or tapes. Many people do not take kindly to having their picture published without permission and they may not want their recorded voice deposited in an archive. Tribes can confiscate recording devices if they are used improperly.

5. Fair and appropriate return should be given to informants. This can be in the form of money, a copy of the book, or an acknowledgment, depending on the agreement between the investigator and the informant. Some researchers balk at this, but considering that the writer/researcher is the one who usually benefits from the study, fair return is just that—fair. Otherwise, the researcher has used the informant for his or her own gain. Informants have a right to remain anonymous, but proper credit must be given to informants who do wish to be acknowledged.

6. The anticipated consequences of the research should be communicated to individuals and groups that will be affected. What is likely to happen? Potential informants may not want to be involved after hearing about the entire process and the researcher will end up with half a study—so do not be secretive. The researchers should inform the tribe of pub-lishing houses or journals that may print results of the study.

7. Every attempt should be made to cooperate with the current host society. An unfortunate scenario for some scholars could be that one political party will be in power when the research proposal is approved, but another political entity unsupportive of the project may come to power before the project is completed. Bob Trotter, Chair of the Department of Anthropology at N.A.U. and a member of N.A.R.G.A.C., tells a story of a student who was almost finished with her disseration on a tribe in South America when a new political

party — different from the one which had given her permission to study the tribe — took command and made her leave. She also had to surrender ten years worth of notes and leave what she had written of her dissertation behind.

Obviously, problems must be anticipated. Written agreements may not have the same meaning and legal exigency for all peoples. Some may agree to the project then they may turn around later and become uncooperative. Researchers at N.A.U. are encouraged not to take on a project with a group that is politically unstable, because the researcher may have to abandon the project.

8. *Physical anthropologists, archaeologists, and other researchers wishing to desecrate Indian burials in order to study Indian remains and funerary objects should obtain permission to do so from tribes.* The issues of desecration of Indian burials and sacred objects, the study of the remains and objects, and the repatriation of these items to tribes is quite volatile and multi-faceted. Researchers should realize that the study of the past does impact on the present, and they need to understand that activities that some scholars see as academic study are viewed by Indians as grave robbing.

Those who study Indian remains should respect the dignity of living Indians by not plundering graves without permission from the descendants of the deceased. Researchers should be aware of the Native American Graves Protection and Repatriation Act (N.A.G.P.R.A.) that restricts the desecration of Indian graves, and they should check state laws that have enacted criminal prosecution for trafficking human remains.

9. *Results of the study should be reviewed by the tribes' elected representatives and religious leaders.* Many researchers object to having non-scholars critique their writings. But this step is vital. It ensures that sensitive information remains secret and that the researcher presents acceptable information correctly. A PhD should not be viewed as a license to obtain everything about tribal histories and culture, nor should a researcher with a terminal degree consider himself or herself an "expert" on Indian matters. In actuality, many Indians do know more about the topic than the researcher, although the former may not have completed high school. Not enough researchers ask for Indians' input anyway and their studies could be improved if they did.

10. *The researcher must follow the guidelines for each new project.* Some tribes as a whole have no problems with or objections to academic research and publication of data about their cultural heritage — but many do. Just because a researcher had a fruitful experience with one tribe does not mean the next tribe will welcome him or her with open arms. All tribes are different. Where some welcome research, others view it as violating their privacy and the sanctity of their traditions.

Many tribes have indeed been exploited. Failure to respect Indians' wishes concerning research could hamper the plans of future researchers.

Establishing guidelines for academic research is not easy. The five of us spent over a year gathering the conduct standards and ethics statements of various disciplines. We met once a week to share ideas and argue, to present worst-case scenarios, and to meet with local tribal representatives. Every time one person offered a comment, someone else was ready to play devil's advocate. It is indeed inevitable for a committee given the mandate to construct rules and regulations for those scholars who deal with Indians to encounter differences of opinion (imagine the discourse between a physical anthropologist who specializes in human paleobiology and an American Indian professor who champions the repatriation of Indian remains). In order to keep discussions manageable, a guidelines committee should be small, no more than seven people, including Indians and non-Indians who are knowledgeable about Indians' societies and the disciplines involved. It is strongly recommended that the committee seek advice from their institution's attorney and from local tribes.

One of the most difficult aspects of this process is establishing grievance procedures to address those researchers not adhering to guidelines. Most universities have developed policies to deal with misconduct in research, such as plagiarism, and fabrication of data, but opportunistic researchers will find loopholes to slip through and some will take advantage of ambiguous language. Unless a wayward researcher is faced with an explicit set of misconduct rules and regulations, he or she will attempt to publish sensitive and protected data without fear of punishment.[3]

It is vital that the institution be willing to adopt the guidelines as policy, otherwise it is a useless endeavor to create them. The guidelines need to be approved at every level of the institution, and every researcher must be required to adhere to them; otherwise, there will be exceptions to the rules. When the administration finances research efforts for the publication of data a tribe does not want disseminated, it is a sure thing that others will attempt to gain the same favor. After approval of the guidelines, copies should be distributed to all faculty and students wishing to conduct field research with American Indians, and they should sign a consent form stating that they have read and will adhere to the guidelines.

Researchers should not look upon Indians as curiosities. Everyone who conducts research on Indians needs to ask themselves seriously why they do such research. Who is benefitting? All of us need tenure and promotion, grant money, and a good professional reputation. But are the people we study also benefitting? Professors and graduate students who have "always been interested in Indians" need to understand that Indians do not exist just so they can acquire merit or graduate.

Appendix C: Guidelines for Research on American Indians

We need to minimalize useless research. Does the world really need another book on the Cherokee removal process? Or another book on Navajo religion? Maybe so if the tribes say we do, but time could be better spent by discerning what Indians need to know and then working with them to find that knowledge. We should encourage Indians to conduct their own research, and that is why it is important that universities be committed to their education.

No set of guidelines will work in all situations. Often, agreements must be made on a case-by-case basis. The entire focus of establishing and following guidelines should be based on respect, dialogue, and compromise — not on who has the right to study Indians because members of their profession have always done so.

NOTES

This article is a version of my paper given at the conference, "Contemporary Issues in Human Subjects Research: Challenges for Today's Institutional Review Boards (I.R.B.s)," February 12, 1993, in Tempe, Arizona.

[1] Members of the Northern Arizona University Native American Research Guidelines Advisory Committee are: Devon A. Mihesuah, Chair, (Department of HIstory); Nicholas J. Meyerhofer (Department of Modern Languages); Shirley Powell (Department of Anthropology); Robert T. Trotter II (Department of Anthropology); and Peter L. van der Loo (Department of Humanities and Religious Studies).

[2] N.A.U.'s guidelines and my ideals for guidelines are slightly different. The exact wording of the *Northern Arizona University Native American Research Guidelines Advisory Committee Document's* "Statement of Principles" (part III, pp. 2-3) are as follows:

1. Where research involves acquiring material and information that is transferred on the assumption of trust between persons, it is axiomatic that the rights, interests, sensitivities, and well-being of those individuals involved in the study be safeguarded.

2. The aims of the investigation should be communicated as clearly and with as much lead time as possible to all parties involved in the study.

3. Informants have a right to remain anonymous or to be specifically named and acknowledged, if they so choose. The right should be respected where it has been promised explicitly. These strictures apply to the collation of data by means of cameras, tape recorders, and other data gathering devices, as well as to data collected in face-to-face interviews or in participant observation. Those being recorded should understand the capacities of such devices, and they should be free to reject them if they wish; and if they accept them, the results obtained should be consonant with the informant's right to well-being, dignity, and privacy.

4. Fair and appropriate return should be given to informants.

5. The anticipated consequences of research should be assessed and communicated as fully as possible to the individuals and groups likely to be affected. In the case of historic or archaeolgical research on deceased populations, descendants are considered affected groups.

6. Every effort should be exerted to cooperate with members of the host society in the planning and execution of research projects. However, because the host society itself can be divided into opposing or competing factions along geographical, class, political, religious, and other lines, the investigator must apply judgement based on the general principles stated above. Should a particular research project result in significantly increased tribal tension and factionalism, for example, it is advisable that said project at least temporarily be abrogated.

7. Any report, publication, film, exibition and other work should be deposited with the Native elected representatives, elders, and/or traditional leaders of the community. Every effort should be made to ensure that representative bodies have an opportunity to review materials that result from work undertaken in the community.

8. All the above should be acted upon in full recognition of the social and cultural pluralism of societies. This diversity complicates choice-making in research, but ignoring it leads to irresponsible decisions.

3. Guidelines dealing with misconduct in research include: Health Research Extension Act of 1985 (P.L. 99-158); the National Institute of Health's Interim Policies and Procedures for Dealing with Possible Misconduct in Science *(NIH Guide Special Issue*, vol. 15, no. 11, July 18, 1986); National Science Foundation regulations (52 CFR 24466, effective July 1, 1987); and the National Health Service's *Responsibilities of Awardee and Applicant Institutions for Dealing with and Reporting Possible Misconduct in Science* (54 CFR 32446, effective November 8, 1989).

APPENDIX C
OUTLINE FOR SAMPLE SURVEY COURSE
ON AMERICAN INDIAN
HISTORY AND CULTURE

A course on American Indians should include the following objectives:

1. to recognize stereotypes, their sources and why they are damaging
2. to understand the diversity and complexity of tribal histories and cultures
3. to appreciate the contributions of American Indians to their tribes and to non-Indian cultures and societies
4. to understand the current roles of American Indians in today's society

CLASS TOPICS (see chapters in this book for recommended readings):

Stereotypes of Indians (Introduction)
What are some damaging stereotypes of Indians and what are their origins?

Why are the terms "Native Americans" and "American Indians" not really accurate labels for the indigenous peoples of this hemisphere?

The Writing of American Indian History and Interpretations of Cultures (Introduction, Chapter 4)
What is "ethnocentric bias?"

Who was Frederick Jackson Turner and how has he influenced American Indian history writers?

Do you think that it is possible for a person of one ethnic or cultural group to write accurately about persons of other groups?

Did the Europeans bring "civilization" to Indians, or were the tribes already civilized with viable cultures? Give your definition of "civilization" and cite examples of tribal cultures to support your answer.

Indians of North America (Chapter 1)
List specific tribes of the Southwest, Southeast, Plains, Great Basin, Plateau, Arctic, Canada and Northwest.

How are Indian tribes different from each other?

Describe seven different styles of tribal homes.

The Europeans Arrive (Chapters 2, 4)
Who was Christopher Columbus and what was he looking for?
Why is Columbus called the "Discoverer of America?"
How did Columbus treat the Indians he encountered?
What has been the result of the encounter?

Conflict of Civilizations (Chapter 4)
What were Europeans' impressions of the tribes they encountered?
Where did they believe Indians fit into the scheme of life?
What were some of the policies implemented by Euro-Americans to contain the tribes?
How did colonization affect tribal gender roles and the status of men and women?

Populations and Demographics (Chapter 2)
Why is it important to study populations?
What was the population of American Indians in the Western Hemisphere, the U.S., and North America at contact?
What accounted for the tremendous American Indian population loss?

Siberian Land Bridge Theory (Chapter 5)
How do theories of archaeologists and creation stories of tribes differ over where Indians emerged?

Indians' contributions to the Americas (Chapter 7)
Name some New World plants and animals Europeans had never seen.
What are other contributions of Indians to past and present societies?

English-Indian Relations (Introduction, Chapter 4)
With which tribes did the English interact?
How did Puritans view Indians?
What was the Great Chain of Being?
What did the English believe were prerequisites for civilization?
What happened at the first "Thanksgiving" and shortly afterwards?

French-Indian Relations (Chapter 4)
How did the French differ from the British in their views of Indians?
Which tribes sided with the French during the colonial period and why?
Did French trappers adopt the lifestyles of tribes? Why?

Spanish-Indian Relations (Chapter 4)
How did the Spanish deal with the tribes of the Southwest?
What was the "mission system"? Was it successful?
How did the Spanish influence tribes of the Southwest culturally?

Dutch-Indian Relations (Chapter 4)
What tribes did the Dutch encounter and where?
How did the Dutch traders and farmers treat the Indians?
The Dutch stayed for a short time in the New World, but what impact did they have on the tribes they encountered?

Russian-Indian Relations (Chapter 4)
What did the Russian sailors want from the tribes they encountered and how did they go about getting it?
How did the Russians affect the native population and the ecosystem of the Arctic?

Andrew Jackson and Indian Removal (Chapter 4)
Where was Indian Territory?
Why was the Southeastern tribes' removal known as the "Trail of Tears?"
Why were the Southeastern tribes removed?
Were other tribes moved to Indian Territory besides Southeastern tribes?

Fight for the West (Chapters 4, 6)
What precipitated the major confrontations between Indians and Euro-Americans such as the Massacre at Sand Creek, Red Cloud's War, Grant's Peace Policy, Custer's defeat, the Cheyenne's long walk home, the Long Walk of the Navajos, the flight of the Nez Perce, the Apache Wars, and the Massacre at Wounded Knee?
Why was Custer's defeat the Indians' "last hurrah?"

Forced Assimilation (Chapter 4)
Why were Indians forced to school?
What were the negative aspects of the boarding and missionary schools?

Allotment (Chapter13)
What was the Dawes Severalty Act? Why was it passed? Was it beneficial or detrimental to tribes?
How many acres of land did tribes lose though allotment?

Indian Reorganization Act (Chapter 13)
The I.R.A. has been considered both a success and a failure. What are three instances of each?

Termination and Relocation (Chapter 13)
Compare and contrast the termination and relocation policies.
What was termination and why was it so disastrous for tribes?
Who supported termination? Who benefited from it?
When did termination formally end?

Indian Identity (Chapter18, 19)
Many tribes have been rent by dissension over land, culture, education, etc. What are some examples of intra-tribal disagreements?
Define "Indian." (give governmental, B.I.A. and tribal definitions)
Why is ethnic fraud a problem for Indians?

Indian Religions and "New Age" (Chapter 10)
Why do Indians prefer to keep their traditional religions secret?
Why are Indians concerned about some New Agers' use of tribal religions?

Government "benefits" (Chapter 14)
Why do some Indians receive monies from the government?
What are the prerequisites for Indians to receive governmental aid?

American Indians Today (Chapter 7, 9-23)
What are some tribal powers?
Define "quasi-sovereign domestic dependent nation."
What are American Indian populations today?
Where do Indians work?
What do Indians look like?

GROUP PROJECTS:
1) Students will be assigned to one of the following groups:

1:	Northwest and Alaska
2:	Southwest
3:	Great Lakes
4:	Great Plains
5:	California
6:	Southeast
7:	New England

Each group will present an overview of the tribes of their region, including social, religious, economic and political aspects, in addition to commentary on the similarities and differences between the tribes, how tribes reacted to the European invasion, brief histories, and where they are now.

2) Assign students to one of the following groups that will debate these statements in class:
1. Europeans encountered a sparsely populated wilderness of un-civilized savages.
2. Indians were removed from their homes in the Southeast for their own good.
3. The only solution to the Indian problem was to exterminate them.
4. Indians should have been "civilized;" it was for their own good.

5. Tribes should be sovereign and terminated.
6. There is nothing wrong with using Indian images as sports mascots.

Each group will present their topic in debate form. Students may have to argue for or against a concept they do not agree with, but this is an exercise to help students organize their thoughts and to understand all points of view.

3) Have younger students draw their images of Indians for class presentation. Have them discuss why they believe their ideas.

Texts and Other Suggestions for Teachers:

Duane Champagne. *Native America: Portrait of the Peoples*. Detroit: Visible Ink, 1994.

Gibson, Arrell. *The American Indian: Prehistory to the Present*. D.C. Heath and Co., 1980.

Utter, Jack. *American Indians: Answers to Today's Questions*. Lake Ann: National Woodlands Publishing Co., 1993.

Waldman, Carl. *Atlas of the North American Indian*. New York: Facts on File, 1985.

People Against Racism in Education, *A Thanksgiving Curiculum: Offering a Native Viewpoint* Box 972, Cathedral Station, New York, NY 10025.

JOURNALS:

American Anthropologist
American Indian Culture and Research Journal
American Indian Law Review
American Indian Quarterly
American Quarterly
Chronicles of Oklahoma
Current Anthropology
Ethnohistory
The Indian Historian
Journal of American History
Journal of Ethnic Studies
Journal of the West
Pacific Historical Review
Plains Anthropologist
Western Historical Review
William and Mary Quarterly

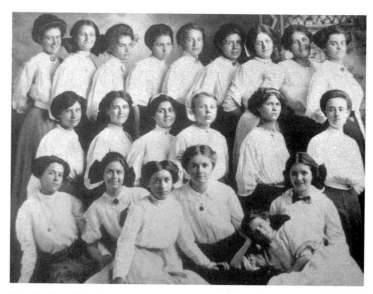

Cherokee Female Seminarians, c 1909. The Cherokee Male and Female Seminaries were established by the Cherokee Nation in 1852 in northeastern Indian Territory. Financed and administered by the tribe, the seminaries were patterned after Mount Holyoke Female Seminary in Massachusetts and Yale. Only members of the Cherokee tribe were allowed to enroll. Many of these students are of mixed ancestry. Graduates became physicians, lawyers, politicians, educators, bankers, and social workers. (Courtesy of Richard Corley).

APPENDIX D
SAMPLE SURVEY COURSE
AMERICAN INDIAN WOMEN IN HISTORY

(This course may be used for upper-division university students, or can be modified for lower-level grades)

COURSE DESCRIPTION:

In the past twenty years, interest in the history and cultures of American Indian women has increased. Yet with a few exceptions, books and articles that focus on Indian women have not adequately portrayed their lives and histories. Despite the plethora of works that have been written about American Indians, the roles and contributions of Indian women have gone unappreciated, and many writings give the impression that all Indian women were and are alike. Many historians and anthropologists purport that Indian women played unimportant tribal roles and that they have always been subservient to men. In reality, Indian women's lives and cultures were multifaceted and they possessed a great deal of political, religious, social and economic power.

Utilizing an ethnohistorical approach, this course will explore the history of the lives of American Indian women from a variety of tribes and will examine four major themes: 1. the methodologies involved when writing about Indian women; 2. finding Indian women's voices; 3. the roles of Indian women in their tribal societies; and 4. the changing definitions of race, class and gender within tribal societies as a result of colonialism.

COURSE OBJECTIVES:

1. to understand the diversity and complexity of Indian women's lives;
2. to understand the roles of American Indian women in their social, political, economic and religious tribal settings;
3. to develop an appreciation of the contributions of Indian women to the survival of their tribes;
4. to learn different methodologies of writing the lives of Indian women; and,
5. to explore and recognize stereotypes of Indian women.

COURSE OUTLINE
(most topics take more than one class period to dicuss):

1. Overview of Indians of the United States
Suggested:Readings:

" A *Ms.* Special Report: Women of the Americas Before Columbus." *Ms.* (Spt/Oct 1992): 20-29; 62; 69.

Arrell Morgan Gobson. *The American Indian: Prehistory to the Present.* D.C. Heath and Co., 1980.

Jack Utter. *American Indians: Answers to Today's Questions.* Nat'l. Woodlands Pub. Co., 1993.

Duane Champagne. *Native America: Portrait of the Peoples.* Visible Ink Press, 1994.

Carl Waldman. *Atlas of the North American Indian.* Facts on File, 1985.

WOMEN'S HISTORY, HISTORIOGRAPHY, CULTURAL LOCATION AND NATIVE WOMEN'S HISTORY

2. Methodology of Writing About Women of Color
Suggested Readings:

Patricia Albers and Beatrice Medicine, *The Hidden Half: Studies of Plains Indian Women.* Lanham: University Press of America 1983); chap. 1.

Gloria Anzuldua, ed. *Making Face, Making Soul/Hacienda caras: Creative and Critical Perspectives by Women of Color.* Aunt Lute, 1990.

Evelyn Brooks-Higgenbotham, "The Problem of Race in in Women's History," in Elizabeth Weed, ed. *Coming to Terms: Feminism, Theory, Politics.* Routledge, 1989, pp. 122-133.

Bernice A. Carroll. *Liberating Women's History: Theoretical and Critical Essays.* Illinois, 1976.

bell hooks, *Ain't I a Woman?* South End Press, 1981.

idem., Feminist Theory: From Margin to Center. South End Press, 1984.

Gloria T. Hull, Patricia Bell Scott, and Barbara Smith, eds., *All the Women are White, All the Blacks are Men, But Some of us Are Brave.* The Feminist Press, 1981.

Aida Hurtado, Gloria Joseph, Cherrie Moraga, and Gloria Anzuldua, eds., *This Bridge Called my Back: Writings by Radical Women of Color.* Kitchen Table: Women of Color Press, 1983.

Gerda Lerner, *Black Women in White America: A Documentary History.* Pantheon, 1972, chaps. 5-7.

Gerda Lerner. "Reconceptualizing Difference Among Women." *Journal of Women's History* 1 (Winter 1990): 106-122

Devon A. Mihesuah, "Commonalty of Difference: Writing About American Indian Women," *American Indian Quarterly,* vol 20, #1 (1996):

Chandra Talpade Mohanty, Ann Russo, and Lourdes Torres, *Third World Women and the Politics of Feminism* Indiana, 1991. Introduction and pp. 314-327.

Marla M. Powers, *Oglala Women: Myth, Ritual, and Reality* Chicago, 1986, introduction.

Alvina Quintana, "Women: Prisoners of the Word," in *Chicana Voices: Intersctions of Race, Class, and Gender* Colorado College, Colorado Springs: National Association for Chicano Studies, 1990, pp. 208-219.

Ann Russo, "We Cannot Live Without Our Lives: White Women, Antiracism, and Feminism," in idem, pp. 297-313.

Rayna R. Reiter. *Toward an Anthropology of Women.* Monthly Review Press, 1975.

Nancy Shoemaker, ed. *Negotiators of Change: Historical Perspectives on Native American Women.* Routledge, 1995, introduction.

Elizabeth Spellman, *Inessential Woman: Problems of Exclusion in Femiist Thought* Beacon Press, 1988.

3. Images of Indian Women

Suggested Readings:

Albers and Medicine. *The Hidden Half.* Chap. 2

Rachel Doggett, ed. *New World of Wonders: European Images of the Americas, 1492-1700* Washington, D.C.: The Folger Shakespeare Library, 1992.

Rayna Green, "Pocahontas Perplex: The Image of Indian Women in American Culture." *Massachusetts Review* 16 (Autumn 1975): 698-714.

Hugh Honour, *The European Vision of America* Cleveland Museum of Art, 1975.

Janet A. McDonnell, "Sioux Women: A Photographic Essay." *South Dakota History* 13 (Fall 1983): 227-44.

Gary B. Nash. "The Image of the Indian in the Southern Colonial Mind." *William and Mary Quarterly* 29 (April 1972): 197-230.

Sherry Smith. "Indian Women" in *View From Officer's Row.* Arizona, 1990, pp. 55-91.

Carol Douglas Sparks, "The Land Incarnate: Navajo Women and the Dialogue of Colonialism, 1821-1870," in Nancy Shoemaker, *Negotiators of Change*, pp. 135-156.

4. Overview of Works on Indian Women

Suggested Readings :

Rayna Green, *Native American Women: A Contextual Bibliography.* Indiana,1983.

G. Bataille and K.M. Sands. *American Indian Women: A Guide to Research.* Garland, 1991.

Idem. American Indian Women: Telling Their Lives. Nebraska, 1984.

5. Interpretation of Cultures

Suggested Readings:

Paula Gunn Allen, " Kochinnenako in Academe: Three Approaches to Interpreting a Keres Indian Tale," in P.G. Allen. *The Sacred Hoop: Recovering the Feminine in American Indian Traditions.* Beacon, 1986. pp. 222-244.

John Van Maanen. *Tales of the Field: On Writing Ethnography.* Illinois, 1988.

Ruth Behar. *Translated Woman.* Beacon, 1993.

Renato Rosaldo. *Culture and Truth.* Beacon, 1993.

James Clifford and George E. Marcus. *Writing Culture.* University of CA, 1986.

James Clifford. *The Predicament of Culture.* Harvard, 1988.

Calvin Martin. "The Metaphysics of Writing Indian-White History." in C. Martin, *The American Indian and the Problem of History.* Oxford, 1987. pp. 27-34.

Clifford Geertz. *The Interpretation of Cultures.* Basic Books, 1973.

Elizabeth Tonkin, et al. *History and Ethnicity.* Routledge, 1989.

Lawrence C. Watson, et al. *Interpreting Life Histories.* Rutgers, 1985.

Margaret Ehrenberg. *Women in Prehistory.* Oklahoma, 1989.

FINDING INDIAN WOMEN'S VOICES

6. Oral History

Suggested Readings:

Susan Geiger. "What's So Feminist About Women's Oral History?" *Journal of Women's History* 2 (Spring 1990): 169-181.

Ahenakew, Freda and H.C. Wolfart, eds. *Our Grandmothers' Lives as Told in Their Own Words.* Fifth House Publishers, 1991.

Michael Frisch. *A Shared Authority: Essays on the Craft and Meaning of Oral and Public History.* Albany: State University of NM Press, 1990.

David Henige. *Oral Historiography.* London: Longman, Inc., 1982.

Angela Cavender Wilson. "Grandmother to Granddaughter: Generations of Oral History in a Dakota Family," *American Indian Quarterly* (1996).

7. Literary Traditions

Suggested Readings:

Works of Paula Gunn Allen, Elizabeth Cook-Lynn, Louise Erdrich, Janet Campbell Hale, Joy Harjo, Linda Hogan, Wendy Rose, Luci Tapahonso, Leslie Silko.

Rayna Green. *That's What She Said: Contemporary Poetry and Fiction by Native American Women*. Indiana University Press, 1984.

8. Autobiographies
Suggested Readings:

Nancy O. Lurie. *Mountain Wolf Woman: The Autobiography of a Winnebago Indian*. Michigan, 1961.

Wilma Mankiller and Michael Wallis. *Mankiller: A Chief and Her People*. St Martin's Press, 1994

G. Bataille and K. Sands. *American Indian Women: Telling Their Lives*. Nebraska Press, 1984

Maria Campbell. *Halfbreed*. Nebraska, 1982.

Qoyawayma Polingaysi. *No Turning Back*. New Mexico, 1964.

Irene Stewert. *A Voice in Her Tribe: A Navajo Woman's Own Story*

Margaret B. Blackman. *During My Time: Florence Edenshaw Davidson, a Haida Woman*. UWash., 1982.

Helen Sekaquaptewa. *Me and Mine: The Life Story of Helen Sekaquaptewa*. UA Press, 1969.

Anna Moore Shaw. *A Pima Past*. UArizona Press, 1974.

INDIAN WOMEN IN TRIBAL SOCIETIES

9. Indian Women and Tribal Power
Suggested Readings:

Albers and Medicine. *The Hidden Half*. chaps. 6, 9.

Paula Gunn Allen. *Grandmothers of the Light: A Medicine Woman's Handbook*. Beacon Pess, 1991.

Karen Anderson. "Commodity Exchange and Subordination: Montagnais-Naskapi and Huron Women, 1600-1650." *Signs: Journal of Women in Culture and Society* 11 (1985): 48-62.

Robert Anderson, "Northern Cheyenne War Mothers." *Anthropological Quarterly* 29 (1956): 82-90.

Nancy Bonvillian. "Gender Relations in Native North America." *American Indian Culture and Research Journal* 13 (1989): 1-28.

Jean L. Briggs. "Eskimo Women: Makers of Men." in Carolyn Matthiasson, ed. *Many Sisters: Women in Cross-Cultural Perspective*. The Free Press, 1974. pp. 261-304.

Jane Fishburne Collier. *Marriage and Inequality in Classless Societies*. Stanford, 1988.

Martha Harron Foster. "Of Baggage and Bondage: Gender and Status Among Hidatsa and Crow Women." *American Indian Culture and Research Journal* 17 (1993): 121-152.

Alice B. Kehoe. "Old Woman Had Great Power." *The Western Canadian Journal of Anthropology* 6 (1976): 68-76.

Clara Sue Kidwell. "The Power of Women in Three American

Indian Societies." *Journal of Ethnic Studies* 6 (1979): 113-21.

Carolyn Niethamer. *Daughters of the Earth: The Lives and Legends of American Indian Women*. Macmillan Pub. Co., 1977. chap. 7.

W.G. Spittal. *Iroquois Women: An Anthology*. Obsweken: Iroqrafts, 1990.

Michelle Z. Rosaldo and Louis Lamphere. *Woman, Culture and Society*. Stanford, 1974.

Nancy Shoemaker. "The Rise or Fall of Iroquois Women." *Journal of Women's History* 2 (Winter 1991): 39-57.

10. Cultural Roles: marriage, ritual, kinship

Suggested Readings:

Albers and Medicine. *The Hidden Half*. pp. 250-261.

Jane Fishburne Collier. *Marriage and Inequality in Classless Societies*. Stanford, 1988.

Charlotte J. Frisbie. *Kinaalda: Navajo Puberty Ceremony*. Wesleyan University Press, 1967.

Martha Harroun Foster. "Of Baggage and Bondage: Gender and Status Among Hidatsa and Crow Women."

Niethammer. *Daughters of the Earth*. chaps. 1-4, 8, 9.

Marla Powers. *Oglala Women*. chaps. 3, 4, 5.

Alice Schlegel. *Male Dominance and Female Autonomy*. HRAF Press, 1972.

11. Cultural Roles: child rearing

Suggested Readings:

Neithammer, *Daughters of the Earth* chap. 2

Powers, *Oglala Women*. chap. 3

12. Cultural Roles: religion, politics

Suggested Readings:

Robert N. Lynch, "Women in Northern Paiute Politics." *Signs: Journal of Women in Culture and Society* 11 (1986): 352-66.

Niethammer. *Daughters of the Earth*. chaps. 6, 10, 11.

M. Powers. *Oglala Women*. chaps. 2, 6.

13. Cultural Roles: economy

Suggested Readings:

Lynn Price Ager. "The Economic Role of Women in Alaskan Eskimo Society." in Erika Bourguignon, ed. *A World of Women: Anthropological Studies of Women in the Societies of the World*. NY: Praeger Pubs., 1980., 305-317.

Albers and Medicine. *The Hidden Half*. chaps. 4-7.

Judith K. Brown, "Economic Origin and the Position of Women

Among the Iroquois." *Ethnohistory* 17 (1970): 151-166.

Niethammer. *Daughters of the Earth.* chap. 5.

Sylvia Van Kirk. "The Role of Native Women in the Fur Trade Society of Western Canada: 1670-1830." *Frontiers* 7 (1984): 9-13.

14. Homosexuality

Suggested Readings:

Albers and Medicine. *The Hidden Half.* chap. 9; pp. 243-250.

Paula G. Allen. "Beloved Women: Lesbians in American Indian Cultures." *Conditions* 7 (1981): 67-87

Evelyn Blackwood. "Sexuality and Gender in Certain Native American Tribes: The Case of Cross-Gender Females." *Signs: Journal of Women in Culture and Society* 10 (1984): 27-42.

Walter Williams. *Spirit and the Flesh: Sexual Diversity in American Indian Culture.* Beacon Press, 1986.

INDIAN WOMEN AND CHANGING CULTURES

15. Colonialism

Suggested Readings:

Karen Anderson. *Chain Her by One Foot: The Subjugation of Women in 17th Century New France.* Routledge, 1991.

Kathryn E. Holland Braund. "Guardians of Tradition and Handmaidens to Change: Women's Roles in Creek Economics and Social Life During the 18th Century." *American Indian Quarterly* 14 (Summer 1990): 239-258.

Ignatia Broker. *Night Flying Woman: An Ojibway Narrative.* Minnesota Historical Society, 1983.

Jennifer S H. Brown. *Strangers in Blood: Fur Trade Families in Indian Country.* Vancouver: University of British Columbia, 1981.

Elizabeth Colson, ed. *Autobiographies of Three Pomo Women.* Berkeley: Archaeological Research Facility, Department of Anthropology, 1974.

Carol Devins. *Countering Colonization: Native American Women and Great Lakes Missions, 1630-1900.* University of California Press, 1992.

Mona Etienne and Eleanor Leacock. *Women and Colonization.* Praeger, 1980.

Oscar Lewis. "The Effects of White Contact Upon Blackfoot Culture," in *Anthropological Essays.* New York: Random House, 1970. pp. 137-212.

Maragret Connell Szasz. "'Poor Richard' Meets the Native American: Schooling for Young Indian Women in 18th Century Connecticut." *Pacific Historical Review* 49 (1980): 215-35.

Lucille Winnie. *Sah-Gan-De-Oh: The Chiefs Daughter*. NY: Vantage Press, 1969.

16. Changing Race, Class, and Identity

Suggested Readings:

Bonnie Thornton Dill. "Race, Class, and Gender: Prospects for an All-Inclusive Sisterhood. *Feminist Studies* 9 (Spring 1983): 131-151.

Malcolm McFee. "The 150% Man: A Product of Blackfeet Acculturation," *American Anthropologist* 70 (1969): 1096-1103.

Devon Mihesuah. "Too Dark to Be Angels: The Class System Among the Cherokees at the Female Seminary." *American Indian Culture and Research Journal* 15 (1991): 86-89.

idem. *Cultivating the Rosebuds: The Education of Women at the Cherokee Female Seminary, 1851-1909.* Illinois, 1993.

LaVera M. Rose. "*Iyeska Win*: Intermarriage and Ethnicity Among the Lakota in the 19th and 20th Centuries." M.A. thesis, Northern Arizona University, 1994.

Terry P. Wilson. "Blood Quantum: Native American Mixed-Bloods." in Maria P.P. Root, ed. *Racially Mixed People in America*. Sage Publications, 1992. pp. 108-125.

17. Indian Women in School

Suggested Readings:

Devon A. Mihesuah. "'Commendable Progress': Acculturation at the Cherokee Female Seminary." *American Indian Quarterly* 11 (Summer 1986): 187-201.

Justin Murphy. "Wheelock Female Seminary, 1842-1861: The Acculturation and Christianization of Young Choctaw Women." *Chronicles of Oklahoma* 69 (Spring 1991): 48-61.

Robert Trennert. "Educating Indian Girls at Nonreservation Boarding Schools, 1878-1920." *Western History Quarterly* (July 1982).

18. New Agers and Indian Women

Suggested Readings:

Ward Churchill *Indians Are Us?* Common Courage Press, 1994.

Wendy Rose, "The Great Pretenders: Further Reflections on Whiteshamanism," in M. Annette Jaimes, ed., *The State of Native America: Genocide, Colonization, and Resistance*. South End Press, 1992, pp. 403-422.

Andy Smith. "For All Those Who Were Indians in a Former Life." *Ms.* (Nov/Dec 1991): 44-45.

Laurie Anne Whitt. "Cultural Imperialism and the Marketing of Native America." *American Indian Culture and Research Journal* 19 (1995): 1-32.

19. Indian Women Today

Suggested Readings:

Johanna Brand. *The Life and Death of Anna Mae Aquash.* Toronto: James Lorimer, 1978.

Laurence M. Hauptman. "Alice Jemison: Seneca Political Activist, 1901-1964." *The Indian Historian* 12 (1979): 15-62.

M. Annette Jaimes. "American Indian Women: At the Center of Indigenous Resistance in North America." in M. Annette Jaimes, ed. *The State of Native America: Genocide, Colonization, and Resistance.* South End Press, 1992. pp. 311-344.

Wilma Mankiller and Michael Wallis, *Wilma Mankiller: A Chief and Her People* St. Martin's Press, 1993.

Powers, Marla N. *Oglala Women.* chaps. 7-12.

Gertrude M. Yeager. *Confronting Change, Challenging Tradition: Women in Latin American History.* Scholarly Resources, 1994.

INDEX